D0773593

Dream of a House

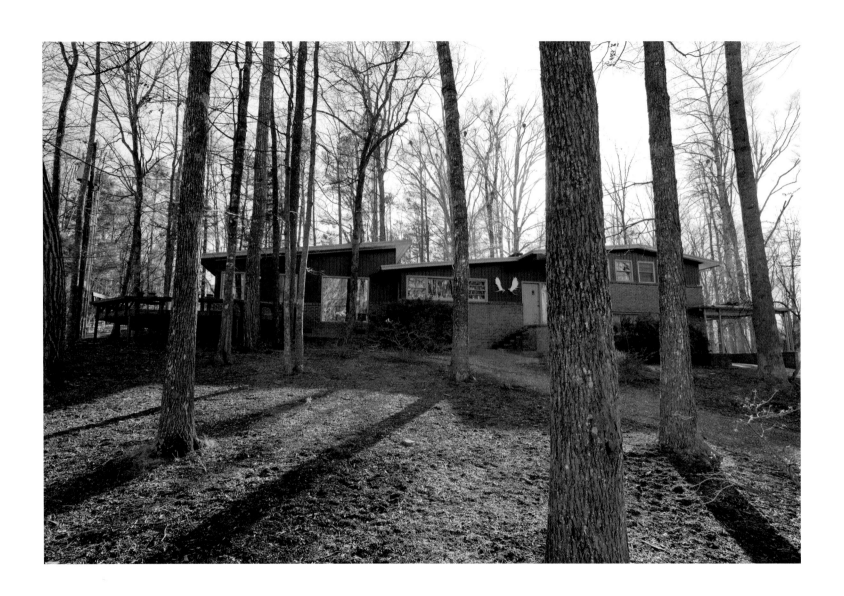

Dream of a House

The Passions and Preoccupations of Reynolds Price

text excerpts and poems from the works of
Reynolds Price

with photographs and an essay by
Alex Harris

edited by
Alex Harris and Margaret Sartor

George F. Thompson Publishing
in association with the
Center for Documentary Studies
at Duke University

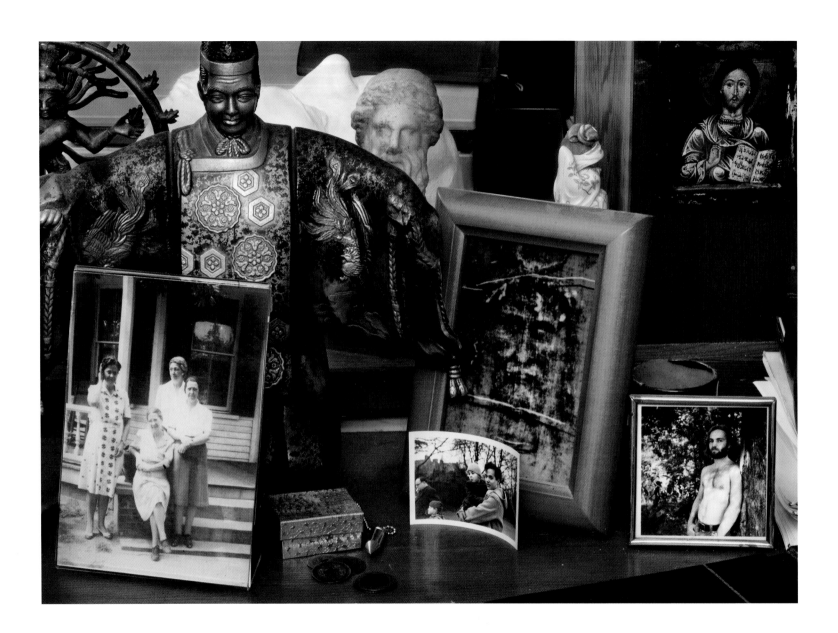

Contents

Dream of a House

A story is an account of something seen, made visible in the telling.

FROM *A Palpable God*

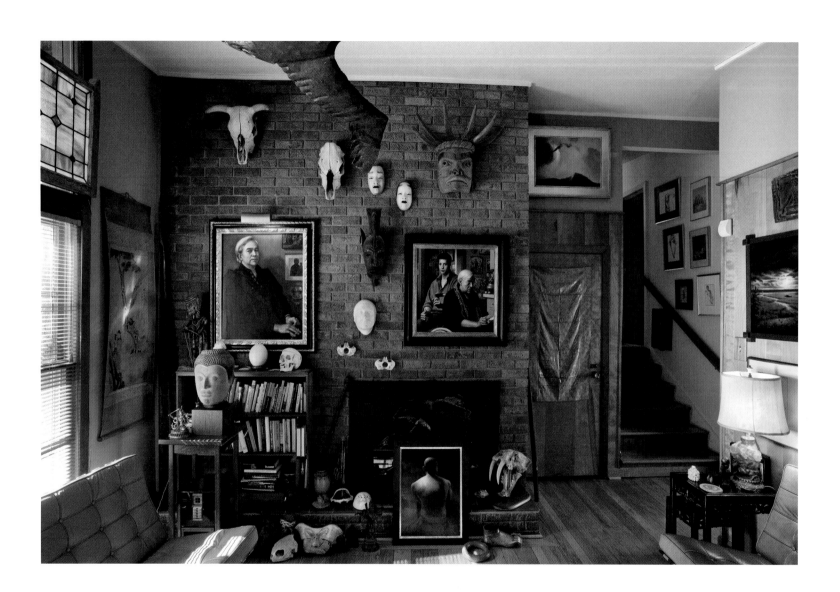

I've lived in the same house for twenty-odd years now which is very unusual in America. I've lived at the same crossroads for thirty-some years. I've taught in the same university for almost thirty years. I live within sixty miles of my birthplace. I've taken pains in my life—I've made conscious choices to try to stay as still as I could, so that I could have that kind of position from which to gauge movement. Movement can only be gauged in stasis.

FROM AN UNPUBLISHED INTERVIEW

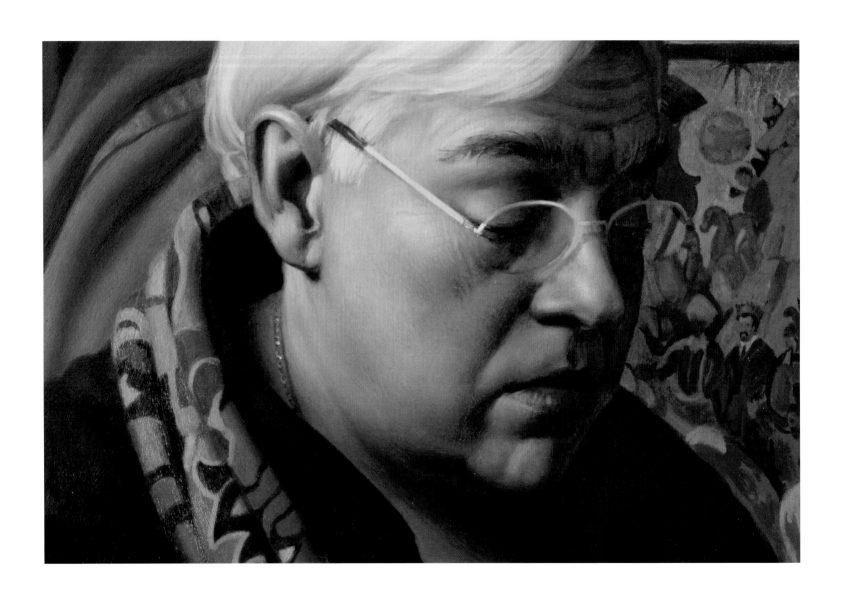

I've always been a very sedentary, certainly a very rooted
person, primarily perhaps because as a child I was forced
to move very frequently. My parents were tossed around
North Carolina by the rigors of the Depression, in search of
money. They were also tossed around the few towns that we
spent several years in by my mother's own restlessness to find
a particular better kind of house or apartment; so I've never
counted up, but I must have lived in twenty houses by the time
I was twenty years old. I hated every single move so that once
I was able to buy this house in 1965, I've really wanted to stay here
and have basically done so with very short stints away—probably
never for longer than two to three weeks at a time. It's a very
important socket into the earth and into the sky for me.

FROM *Conversations with Reynolds Price*

I think I've been for whatever reasons—most of them
obviously utterly unrecoverable—a solitary all my life.
I was an only child; I was eight years old when my brother
was born. We lived either in the country or very much on
the edges of small towns so that I had very few playmates
and had, from my earliest times, to invent my own forms of
entertainment, which took the forms of reading and painting
and the invention of imaginary games, which I played with
myself. For whatever reasons, I like to live alone. Well, I *need*—
I wouldn't say *like*, although I certainly wouldn't claim that
I was unhappy living alone. If I were unhappy living alone,
I'd do something about it; wouldn't I?

FROM *Conversations with Reynolds Price*

In the founding text of our civilization—the Hebrew-Christian Bible—
a spot is sacred forever-after if God or an angel has deigned to touch it . . .
For most of us, the chance of hallowing a place is through human means;
the site of intense and/or prolonged human feeling becomes special for us.

FROM "Homeless. Home."

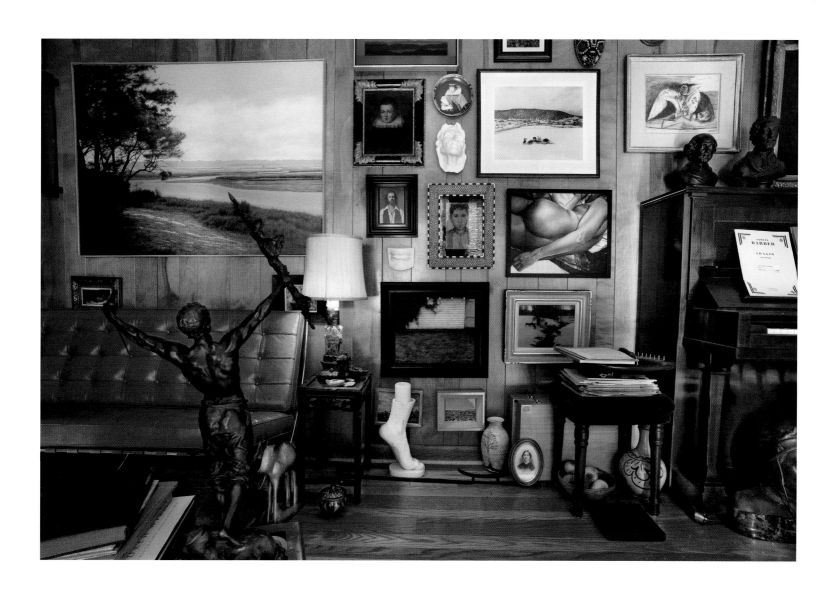

And on the evening of July 11th, of that first slow summer,
as I lay on the floor exercising my legs, there came a call
from a friend of more than two decades. She said simply
"Reynolds, let me read you something." Then in a speaking
voice nearly as rich as her song, Leontyne Price read me
a poem which I'd written and given her in the 1970s.
The poem is called "The Dream of a House," and in it
I transcribed closely a recent dream of my own.

FROM *A Whole New Life*

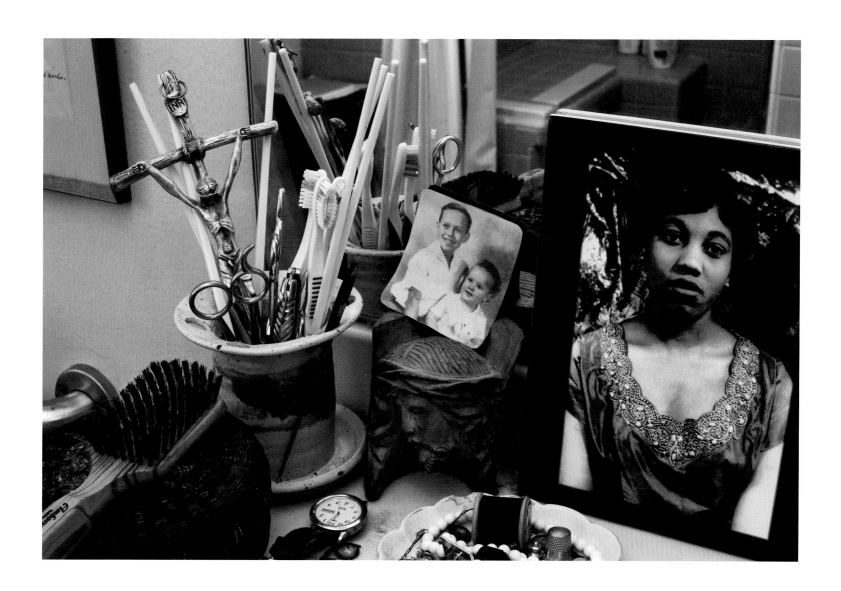

The Dream of a House

There seems no question the house is mine.
I'm told it first at the start of the tour—
"This is yours, understand. Meant for you.
Permanent." I nod gratitude,
Containing the flower of joy in my mouth—
I knew it would come if I waited, in time.
It's now all round me—and I catalog blessings
Tangible as babies: the floors wide teak
Boards perfectly joined, the walls dove plaster.
At either end a single picture,
Neither a copy—Piero's *Nativity*
With angel glee-club, Vermeer's pregnant girl
In blue with her letter. Ranks of books
On the sides—old Miltons, Tolstoys, *Wuthering*
Heights, Ackermann's *Oxford*. A holograph
Copy of Keats's "To Autumn." All roles
Of Flagstad, Leontyne Price in order
On tape, with photographs. Marian Anderson
At Lincoln Memorial, Easter 1939.
A sense of much more, patiently humming.
My guide gives me that long moment,
Then says "You've got your life to learn
This. I'll show you the rest."

I follow and the rest is normal house.
Necessary living quarters—clean,
With a ship's scraped-bone economy. Bedroom
Cool as a cave, green bath,
Steel kitchen. We end in a long
Bright hall, quarry-tiled—
Long window at the far end
On thick woods in sunlight.
The guide gives a wave of consignment—
"Yours"—though he still hasn't smiled.
I ask the only question I know—
"Alone?" He waits, puzzled maybe
(For the first time I study him—a lean man,
Ten years my junior, neat tan clothes:
A uniform?). So I say again
"Alone?—will I be here alone?"
Then he smiles with a breadth that justifies his wait.
"Not from here on," he says. "That's ended too."
But he doesn't move to guide me farther.
I stand, thinking someone will burst in on us
Like a blond from a cake; and I reel through
Twenty-six years of candidates,
Backsliders till now. Silence stretches
Till he points to a closed door three steps
Beyond us.

I cannot go. After so much time—
Begging and vigils. He takes my elbow
And pulls me with him to an ordinary door,
Black iron knob. I only stand.
He opens for me—an ordinary hall
Closet: shelf lined with new hats,
Coats racked in corners. In the midst
Of tweeds and seersuckers, a man is
Nailed to a T-shaped rig—
Full-grown, his face eyelevel with mine,
Eyes clamped. He has borne on a body
No stronger than mine every
Offense a sane man would dread—
Flailed, pierced, gouged, crushed—
But he has the still bearable sweet
Salt smell of blood from my own finger,
Not yet brown, though his long
Hair is stiff with clots, flesh blue.

The guide has never released my arm.
Now he takes it to the face. I don't resist.
The right eyelid is cool and moist.
I draw back slowly and turn to the guide.

Smile more dazzling than the day outside,
He says "Yours. Always."
I nod my thanks, accept the key.
From my lips, enormous, a blossom spreads
At last—white, smell strong as
New iron chain: gorgeous
Lasting, fills the house.

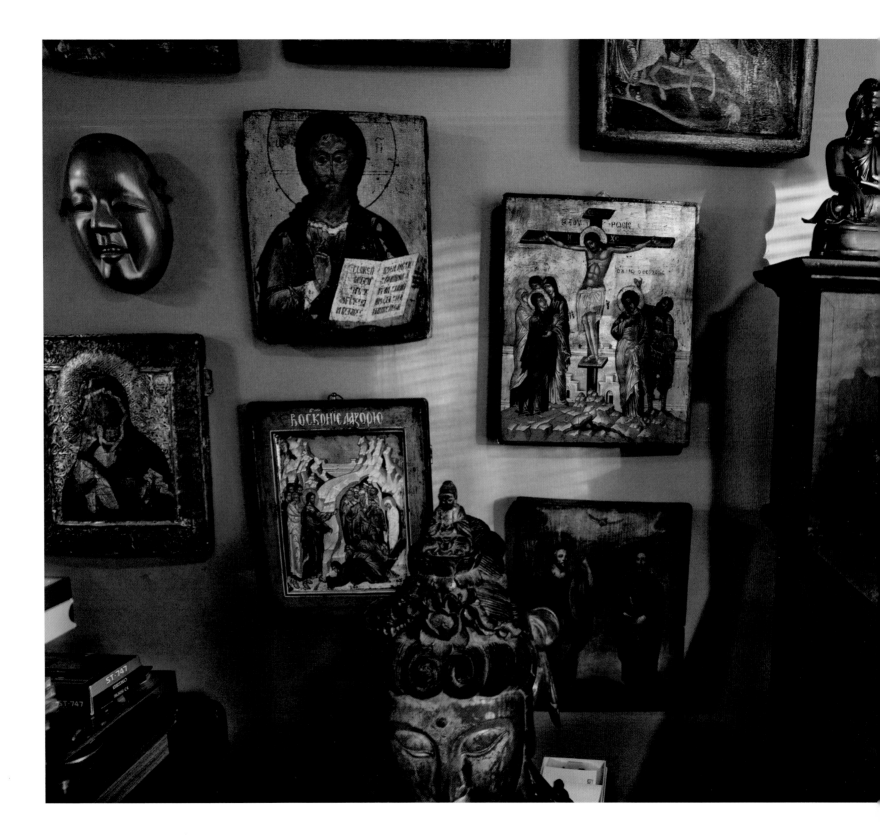

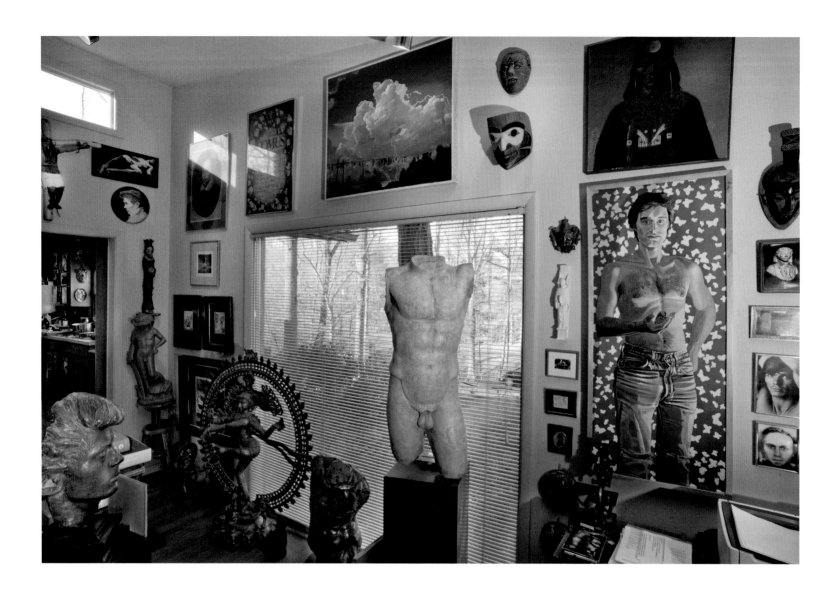

The human body, however groomed and buffed in gymnasia, is an unspeakably fragile organism. Depending on one's genetic heritage, the body appears to perform like an uncomplaining work horse through a fair amount of youthful excess; but in fact it neither forgets nor forgives that excess.

FROM THE INTRODUCTION TO *Faggots*

Back

A whole quarter's silence—
Flesh-colored tunnel with sanguine walls,
No time to speak of pain or fear,
No extra breath (and no real
Fear: fear is the luxury
Two years behind me,
A bourgeois comfort like overstuffed chairs
Or flannel sheets and pain
More nearly a bore today
Than the acid agony that blanked all March).
So *life*, an apparent road ahead
With what seem trees and sky for walls
And natural light. So work. So this.

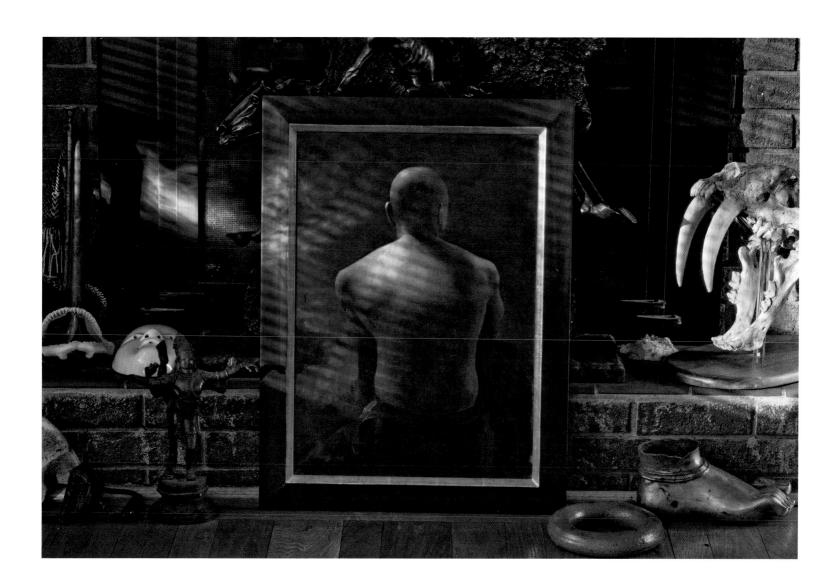

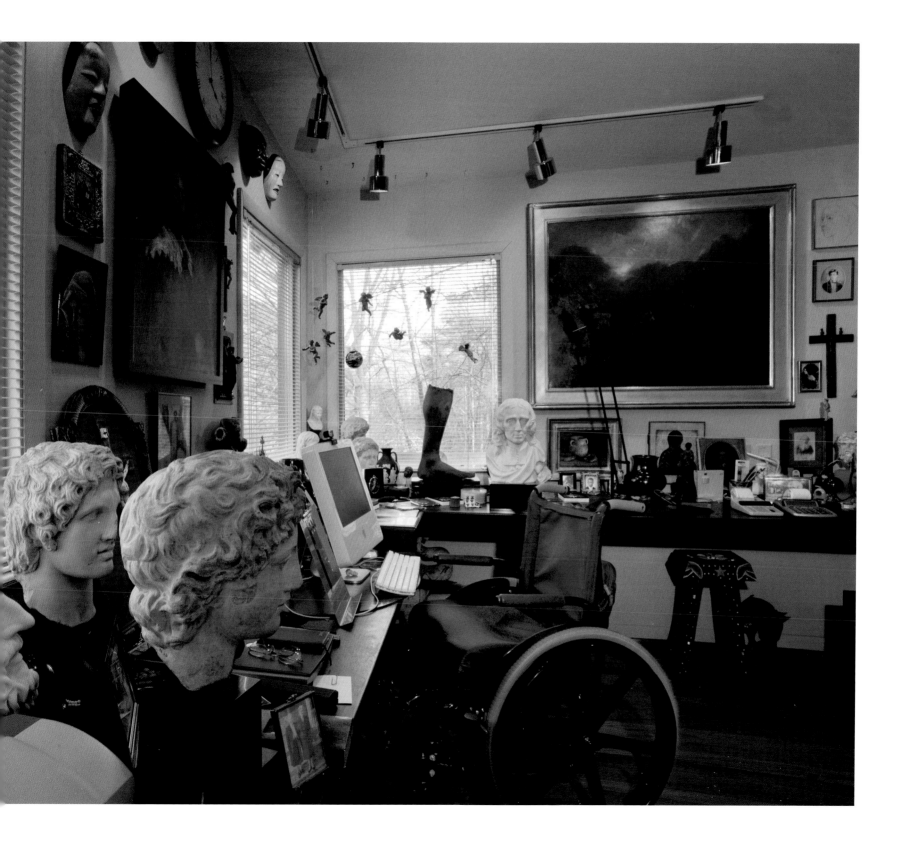

. . . most humans have, often in their late years when pain and loss have all but felled them, a lucid stretch of days or years in which to note that an astonishing majority of humankind—kin, friends and absolute strangers—are capable of turning their own hopeful eyes onto someone else's solitary pain and acting to ease it.

Virtually every one of those creatures, if we could follow their magnanimity to its core, would reveal that they have slowly won that power to hope and to search for harmless goods from the largely visual evidence which life sweeps past them in daily time and in handmade images. Those images are likely to confront us in remembered paintings, drawings, photographs, sculptures, buildings, the green and brown of external nature, and the infinite new potential of images made of no more than charged electrons flashed on a screen.

FROM "The Look of Hope"

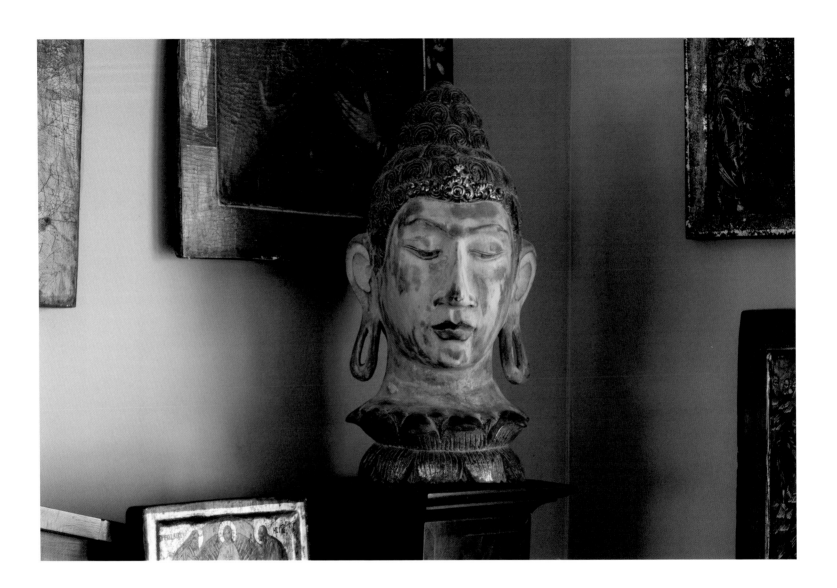

Far more things than we guess in the world are worthy
of our *notice*—whether formed directly by God, Time and
Weather, or by Man. They silently require our concentration,
our slow comprehension, or at least our awe.

<small>FROM</small> "A World to Love at Least"

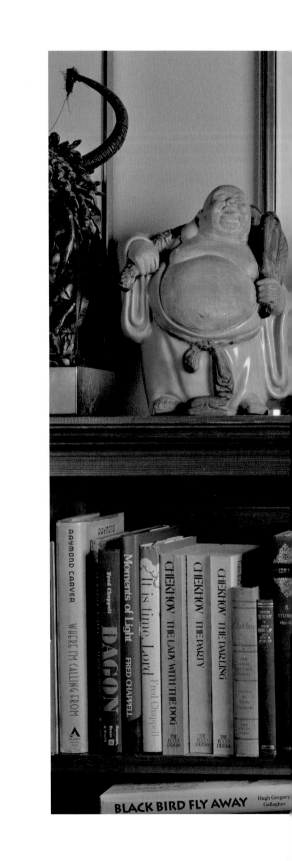

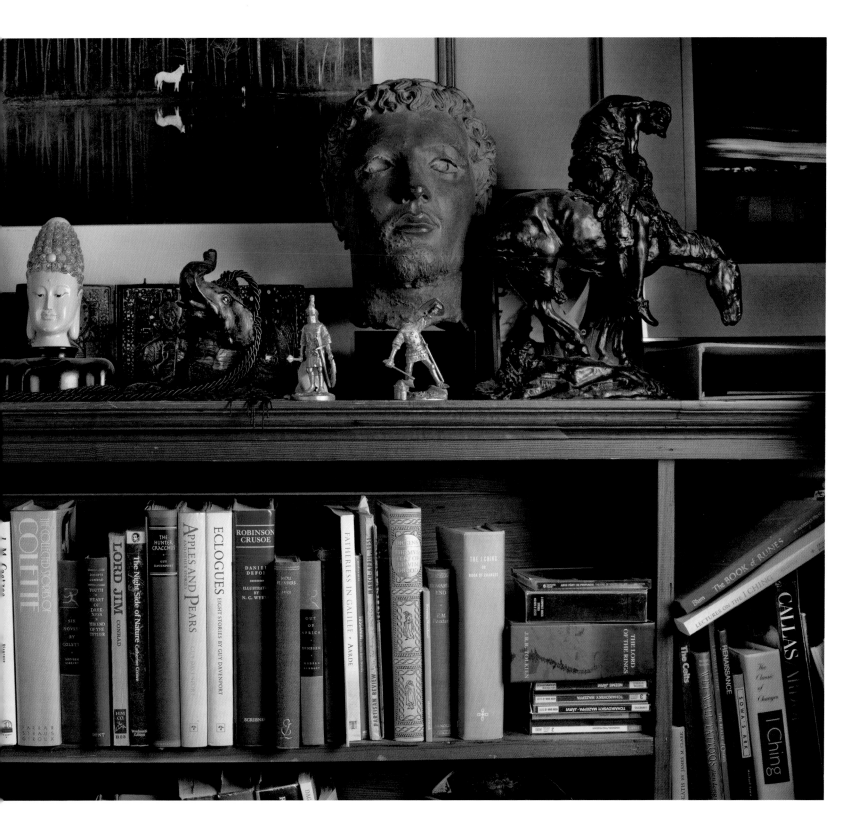

HE SURFACE O

EARLY DARK

PRICE A PA

Human narrative, through all its visible length, gives emphatic signs of arising from the profoundest need of one fragile species. Sacred story is the perfect answer given by the world to the hunger of that species for true consolation. The fact that we hunger has not precluded food.

FROM *A Palpable God*

I'm perfectly prepared to believe that the world is not only
more complicated than we know but than it is ever *possible*
for us to know, simply because we are limited as human beings
by the capacities of our sense organs. There could be incredible
visual phenomena actually occurring in this room right now which
you and I simply can't see—no doubt they *are* occurring—because
our retinas are only capable of responding to a very short portion
of the spectrum of light. The room could be filled with angels,
you know, dancing nude—and we wouldn't know it.

FROM *Conversations with Reynolds Price*

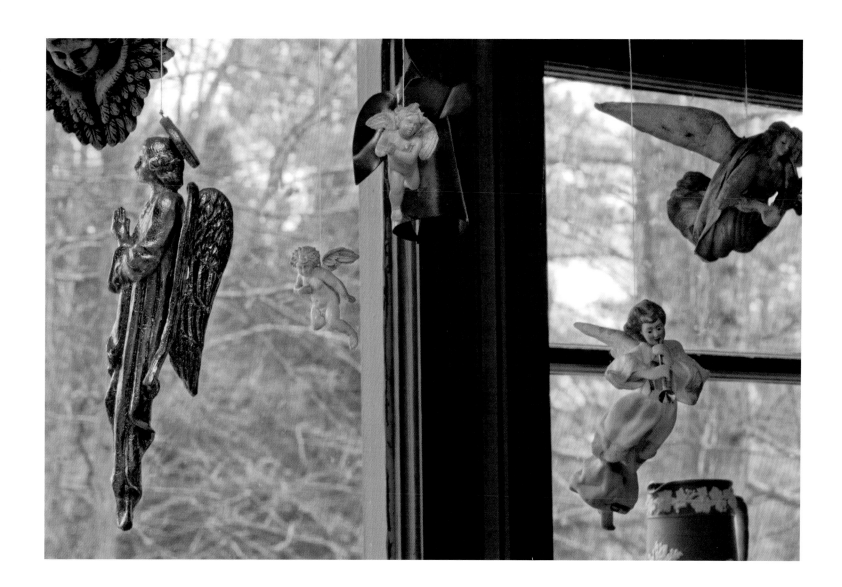

Why do living creatures copy their worlds? Why have we, since the caves at least, tried so consistently to copy, not only the visible world but the unseen world—God or the gods, the black hole we now call evil and the ring of light that circumscribes it? The simplest answer is that all such copies are a copy of the commonest action on the face of the Earth. The whole organic nature is involved in the steady physical effort to reproduce itself.

FROM *Clear Pictures*

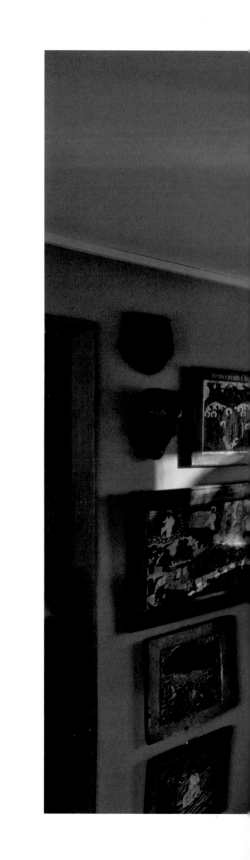

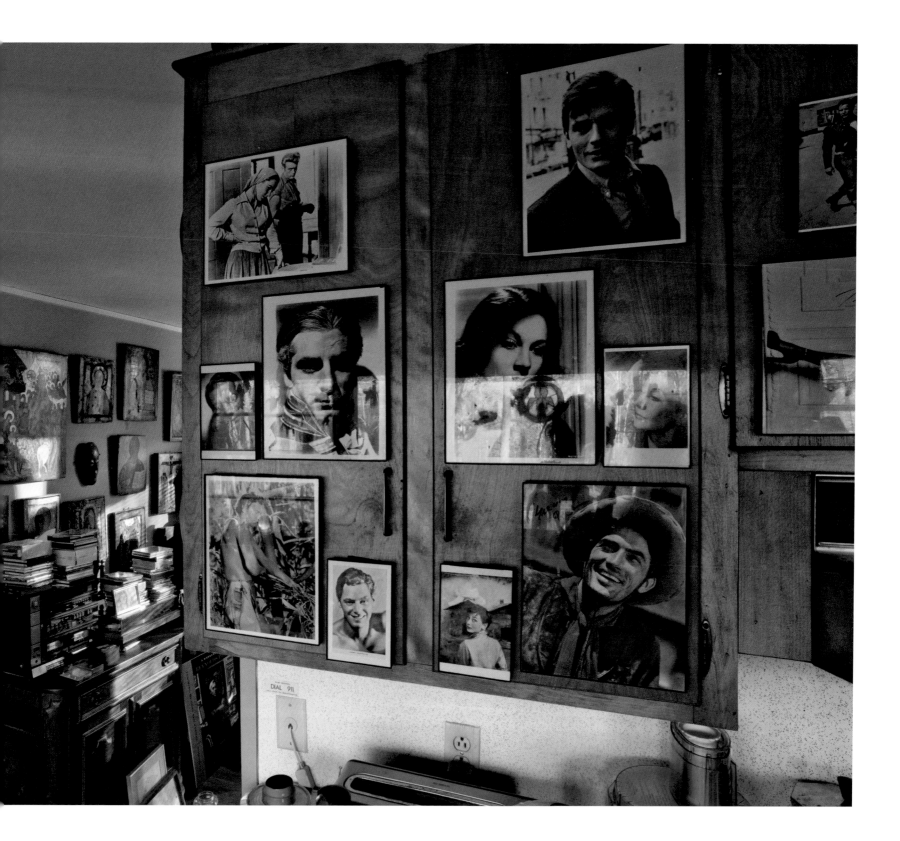

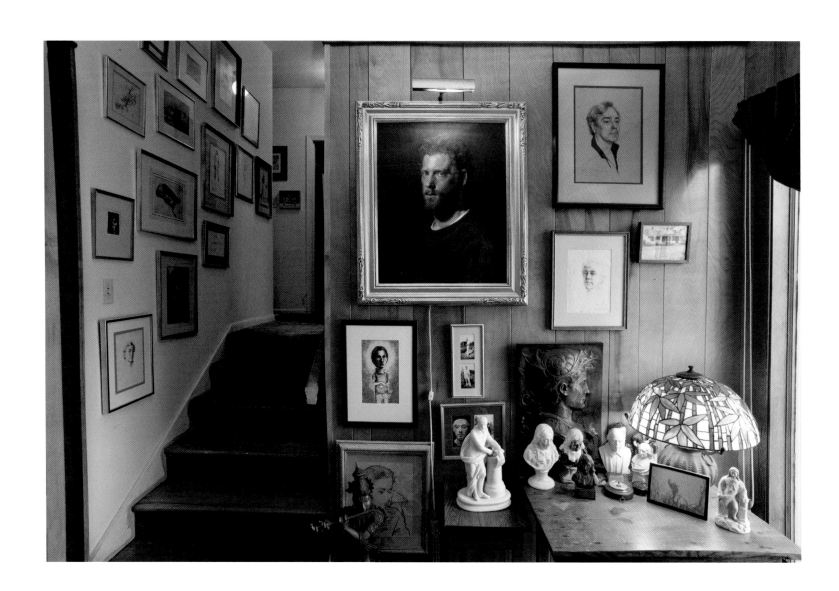

Anniversary, 9 January 1995

Because you mentioned the house this afternoon—
The house embroiled in its late bronze light—
I suddenly guessed I was near a milestone.

When we went to the kitchen cabinet and looked,
There was the posted card inscribed
By Inger and Pietro, thirty years to the day,

To welcome me here with salt, rice, wine.
The rice and wine have come to me, steady,
Three crammed decades. Only the salt

Has poured past limit: tanning my hide.

I'll state it baldly—*I've led a mainly happy life.* I can safely push further. *I've yet to watch another life that seems to have brought more pleasure than mine has to me.*

<small>FROM</small> *A Whole New Life*

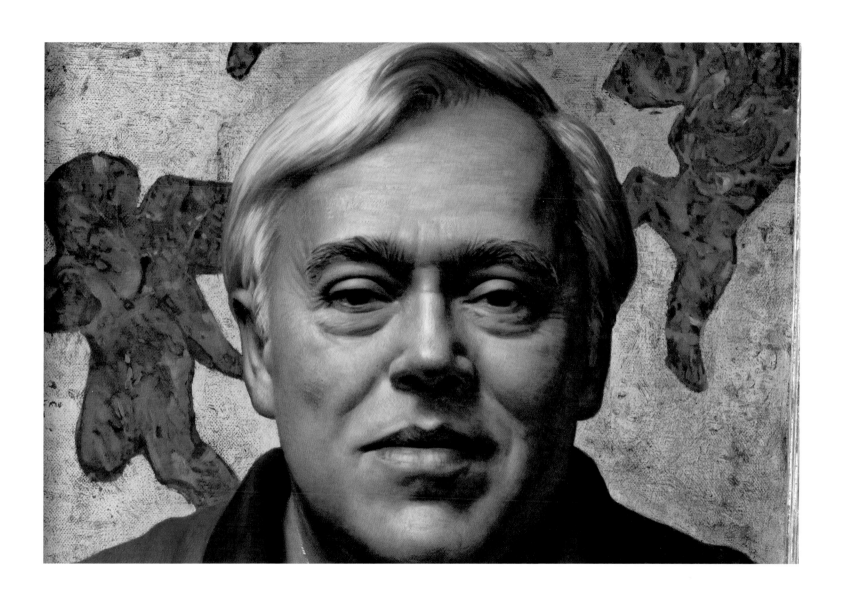

A need to tell and hear stories is essential to the species *Homo sapiens*—second in necessity apparently after nourishment and before love and shelter. Millions survive without love or home, almost none in silence; the opposite of silence leads quickly to narrative, and the sound of the story is the dominant sound of our lives, from the small accounts of our days' events to the vast incommunicable constructs of psychopaths.

FROM *A Palpable God*

OLDS PRICE

A WHOLE NEW LIFE

HE PROMISE OF REST

ICE

THREE GOSPELS

REYNOLDS PRICE

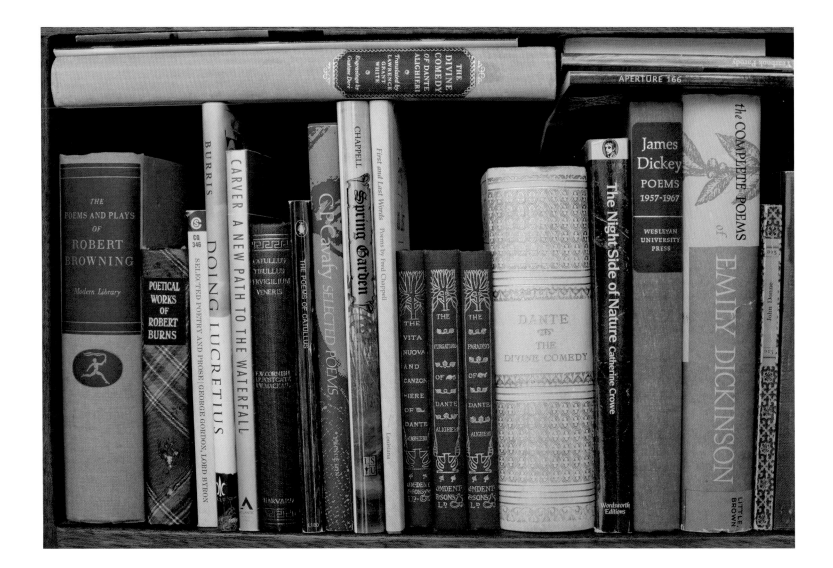

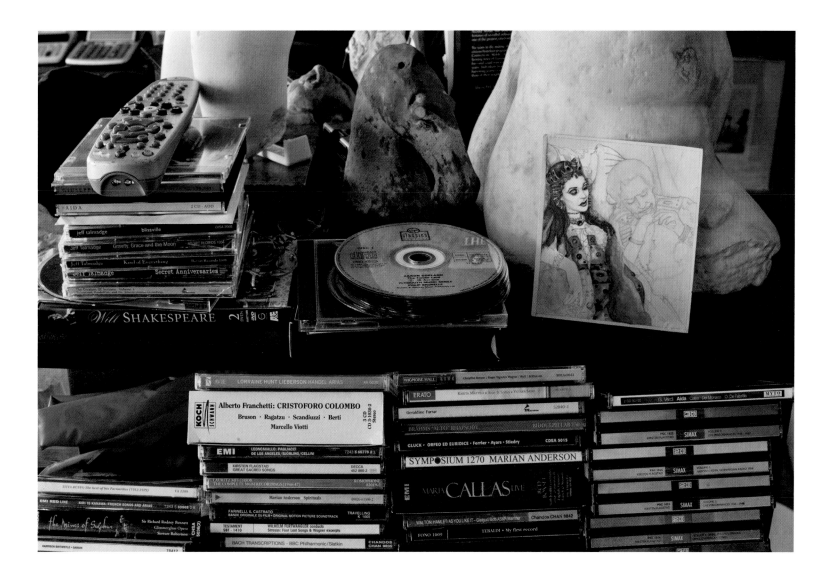

I'm convinced that Americans have mystified the genders to the point of claiming that no man can profoundly understand a woman or vice versa.

That denial is kin to another fashionable mystification—the claim that members of a particular race or ethnic group are sealed off from significant understanding of another group's thoughts and feelings. Plainly, different genders, races, and nationalities have distinguishing tones and convictions. Perhaps they even have hard-wired genetic differences; but if the arts of fiction, drama, and poetry have established anything at all in their long-running careers, it's the fact of the overwhelming similarity of all members of the species *Homo sapiens*. We love and hate, multiply and perish alone in virtually identical ways. Any attempt to deny that fact is an assault on the everywhere visible unity of human emotion, the needs and demands of our bodies and minds.

FROM "Crossing Genders"

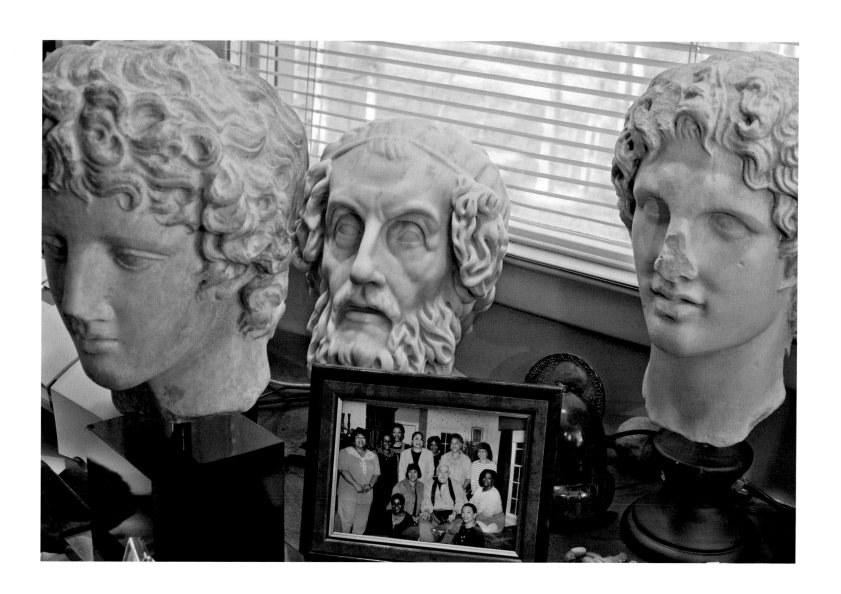

Few readers understand the importance of titles and names
to writers. It is difficult to discuss them at all without sounding
precious or fraudulent; but surely what is involved is no stranger
than the ancient and continuing magic of names—our names are
organic to us, handles to our lives, vulnerable heels; chosen for us
before we were born and our surest survivors, in an age of records.
We all spent solitary hours as children, saying our names aloud until
they metamorphosed from familiarity through abstract sound to
final mystery, essence—so with a novelist who has spent two years
or longer with a carefully named set of characters and with a satisfying
title on his manuscript.

FROM "News for the Mineshaft"

When I lay out the conditions of a character's life, to a large extent writing becomes a matter of just "being them," so that everything that happens from then on is an alternate personality, is an alternate nature. *Kate Vaiden* was the first time I've written a novel in the first person. I made the choice to write the book over a year before I developed this tumor. It was a very nice choice to have made once I got sick because it permitted me every day—while I was going through the bad early phases of this—to be somebody else a lot of the time. I could just sort of go in the study and be this fifty-seven-year-old woman and not this fifty-two-year-old man who was having this mess going on in his life.

FROM AN UNPUBLISHED INTERVIEW

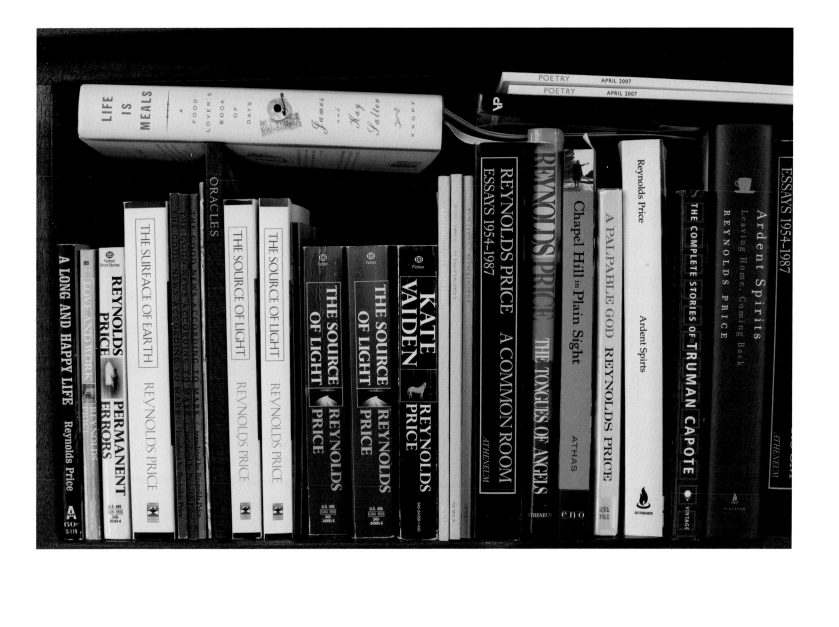

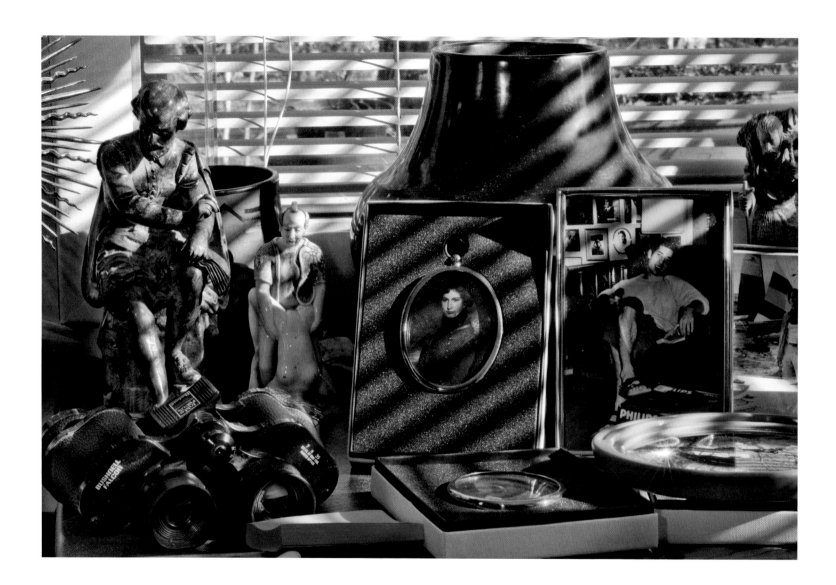

All my work is comic—not by conscious choice but because in attempting to embody the world that I've known, I have portrayed a comic world. Comedy is almost always a function of experience, a function of life. Even in the intensest moments of despair, pain, grief, wild bursts of laughter will insist upon rising and asserting themselves.

FROM *Conversations with Reynolds Price*

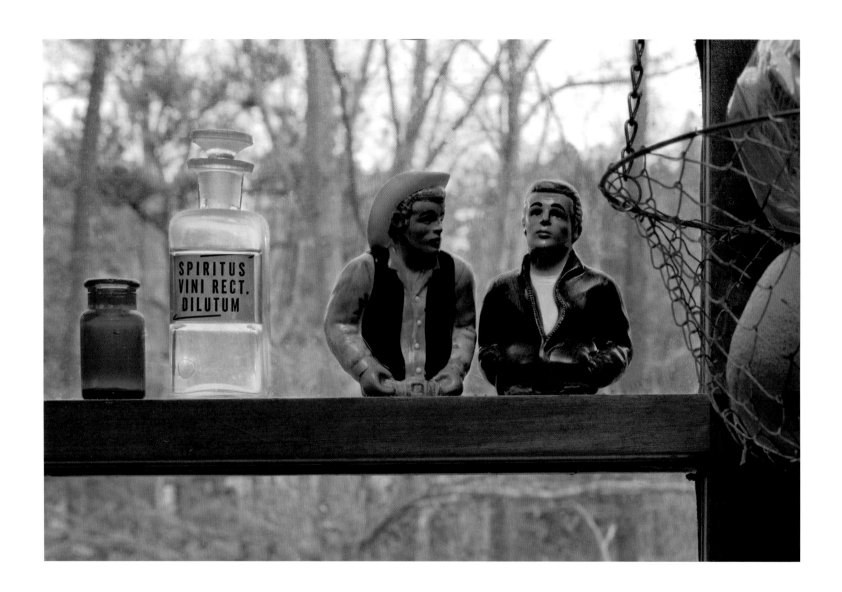

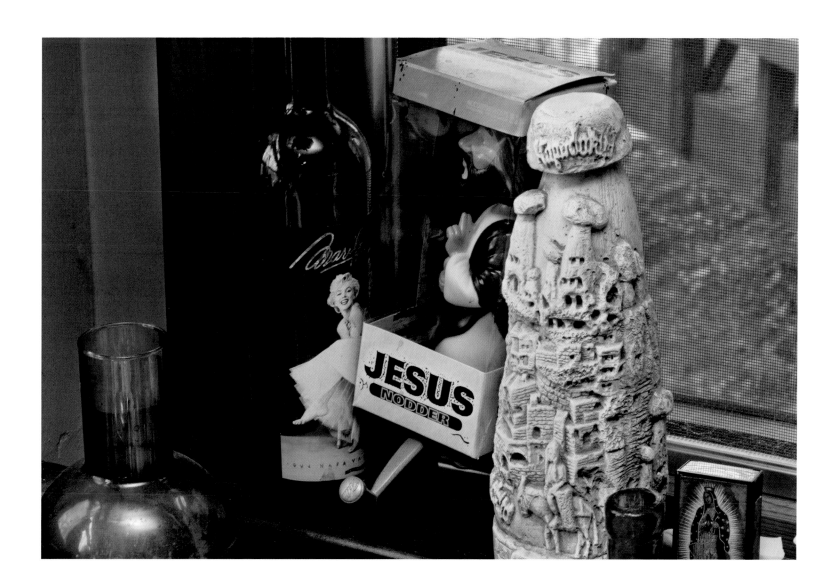

I knew, far back as I remember—well before I started school—
that what was deeply magic for me was the simple presence of
certain men near me in a room or in my head.

FROM "A Final Account"

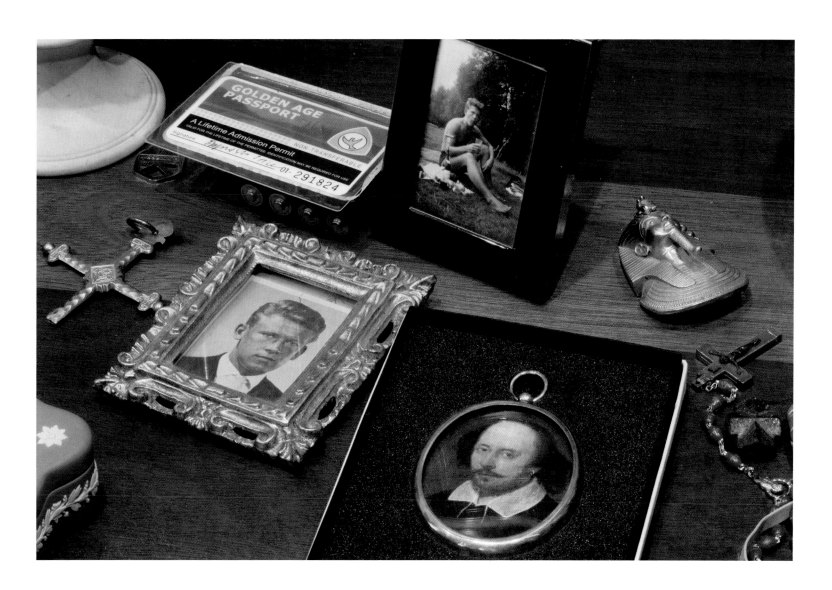

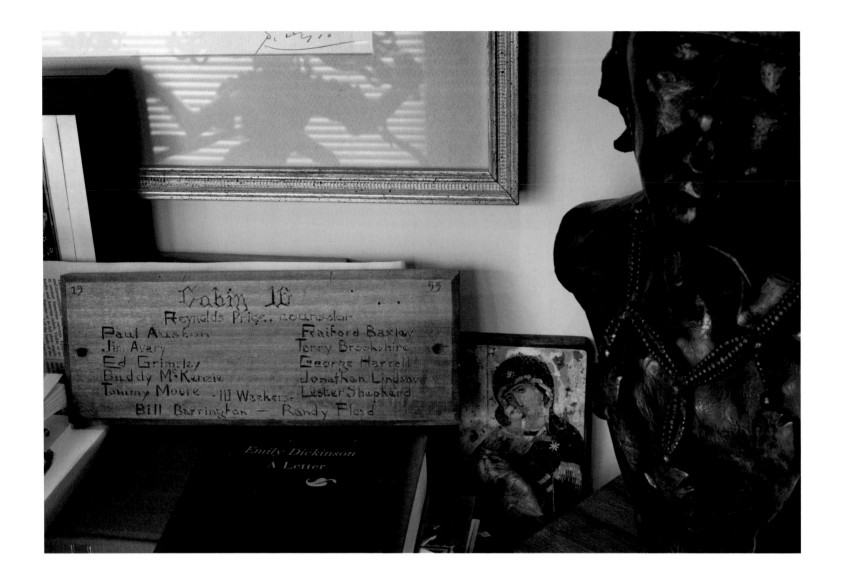

He was the first boy I met at camp. He had got there before me,
and he and a man were taking things out of a suitcase when I walked
into the cabin. He came over and started talking right away without
even knowing me. He even shook hands. I don't think I had ever shaken
hands with anyone my own age before. Not that I minded. I was just sur-
prised and had to find a place to put my duffel bag before I could give him
my hand. His name was Michael, Michael Egerton. He was taller than I was,
and although it was only June, he already had the sort of suntan that would
leave his hair white all summer. I knew he couldn't be more than twelve.
I wouldn't be twelve until February. If you were twelve you usually had to
go to one of the senior cabins across the hill. But his face was old because
the bones under his eyes showed through the skin.

FROM "Michael Egerton"

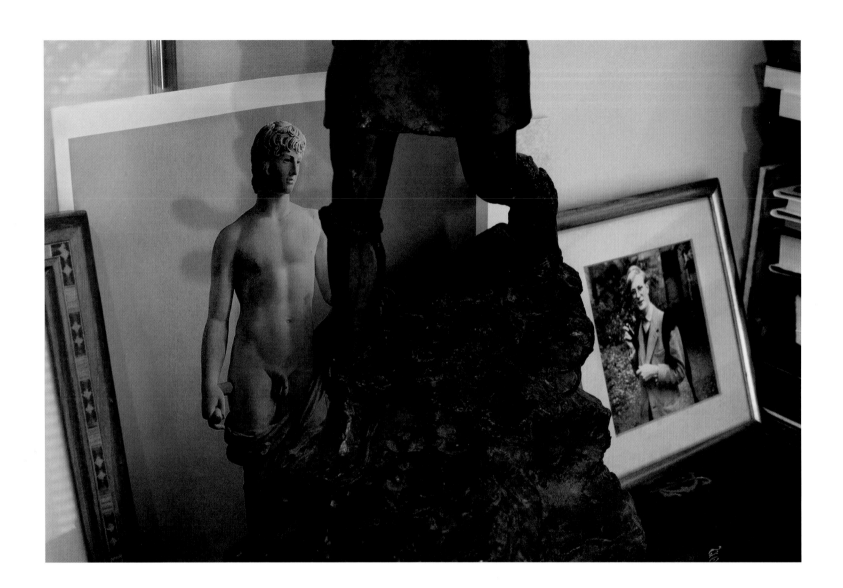

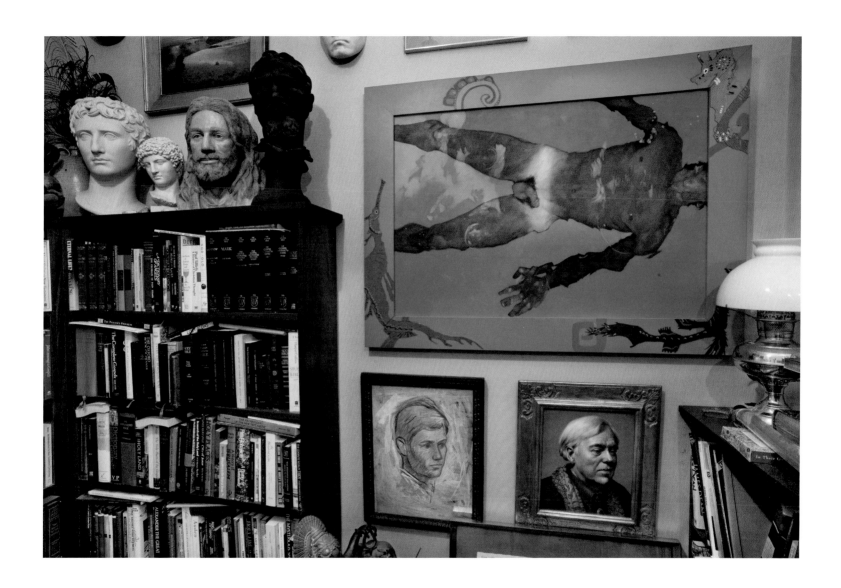

The pictures are images of household gods, I suppose. Images of what I have loved and love and worship—worship in the sense of offering my life and work to them. The pictures are of members of my family— some of whom I never knew, who died before I was born—and of friends who have caused my life and my work. They are here, and here in such numbers, for the sake of my present and future work, not for the sake of nostalgia, not as souvenirs of a lifeless past. That is an aspect of my own work, as it is of almost every artist's work, which is little understood by people who are not themselves artists—the extent to which any work of art, especially verbal art, is a private communication between the artist and a small audience, often as small as one.

FROM *Conversations with Reynolds Price*

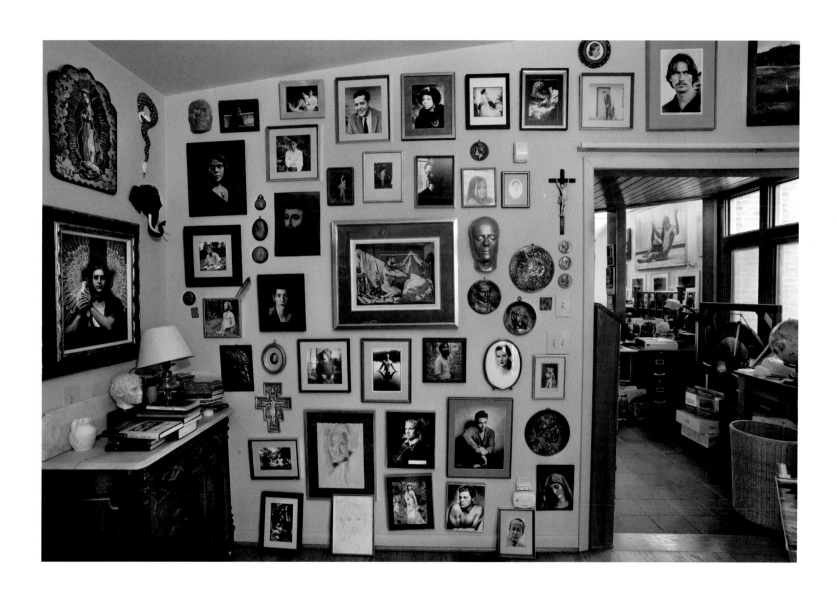

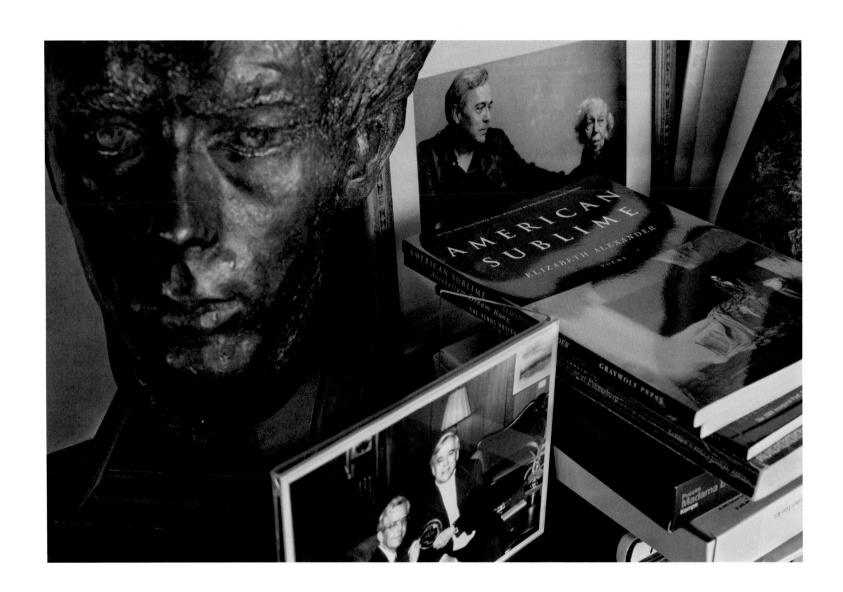

It was in February 1955. Eudora had been invited to give a lecture at the Women's College on East Campus. I had never met her before, but I'd known her works since I was in junior high. I knew she was arriving in town very late at night in the downtown train station, which was immediately behind the courthouse and the jail. I thought, "My God, if you are going to arrive in Durham at three o'clock in the morning, you're in terrible trouble." There'd be no taxis at the station; and she had to get to the old Washington Duke Hotel, which no longer exists. So I just decided that I would go down in the dead of night and meet this great writer and convey her safely through darkest central Durham to the hotel. She seemed pleased and grateful. Our friendship began at that point. We corresponded after that, met whenever we could, and have gone on doing so for the last 28 years [in 1983]. She remembers that I wore a snow-white suit that night; but since it was February, I seriously doubt it. I owned a light gray suit at the time, and I think that's what I must have had on—at least I hope so!

I knew that she was a great writer. The fact that, the next day, she read and praised as professional the only short story I'd yet written—that constituted a final kind of validation for me. If someone that good said *I* was good, then *I* was right to devote the rest of my life to proving her correct. Such a license is the last best thing a teacher can give a serious student.

FROM *Conversations with Reynolds Price*

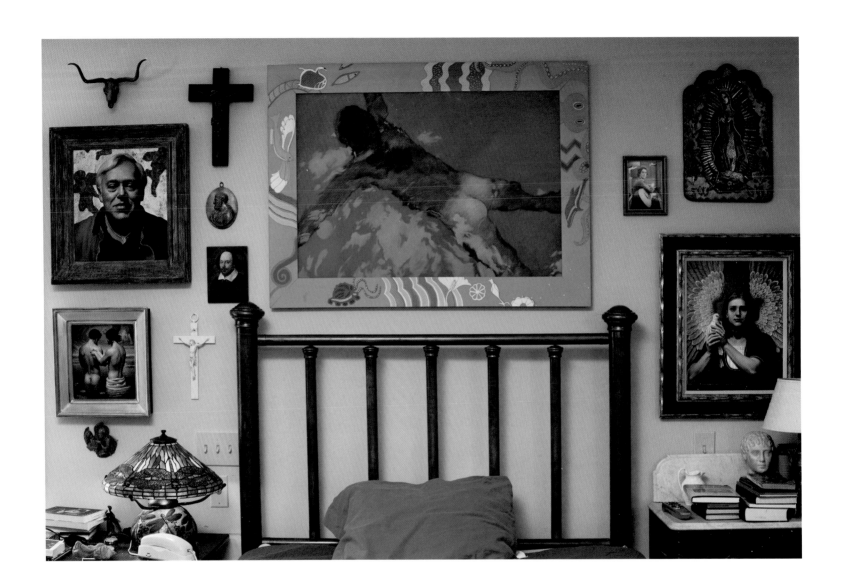

I was well into my thirties before I began to understand that my unconscious mind would—to an amazing extent—compose and deliver my novels, poems, plays, and essays *if* I bothered to give it sane amounts of good food and sleep, sane chemical and emotional nourishment, and then made myself available—six mornings a week—at a quiet desk with the phone turned off and all distractions, short of falling meteors, canceled for the hours it took me to transcribe my mind's ongoing work. It has hardly failed me since, though I grant that a reader who dislikes my work may feel I take dictation from a fool.

FROM "The Ghost-Writer in the Cellar"

Just with his body and from inside like a snake, leaning that black motorcycle side to side, cutting in and out of the slow line of cars to get there first, staring due-north through goggles towards Mount Moriah and switching coon tails in everybody's face was Wesley Beavers, and laid against his back like sleep, spraddle-legged on the sheepskin seat behind him was Rosacoke Mustian who was maybe his girl and who had given up looking into the wind and trying to nod at every sad car in the line, and when he even speeded up and passed the truck (lent for the afternoon by Mr. Issac Alston and driven by Sammy his man, hauling one pine box and one black boy dressed in all he could borrow, set up in a ladder-back chair with flowers banked round him and a foot on the box to steady it)—when he even passed that, Rosacoke said once into his back "Don't" and rested in humiliation, not thinking but with her hands on his hips for dear life and her white blouse blown out behind her like a banner in defeat.

THE FIRST SENTENCE FROM *A Long and Happy Life*

My work then is what all honorable work is—the attempt to control chaos. It has freed me till now from physical want, from prolonged dependence on my fellows, and occasionally from myself. It has freed me for the attempt to understand, if not control, disorder in myself and in those I love. It has even freed me at times to participate in the richest, most dangerous mystery of all—the love of what otherwise I should have feared and fled, a few human beings.

FROM "Finding Work"

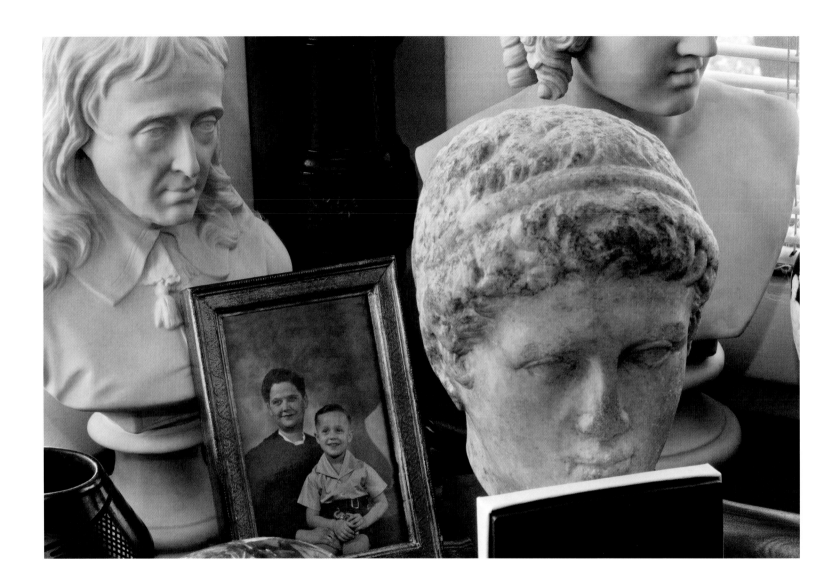

I'm the son of brave magnanimous parents who'd have offered both legs in hostage for mine, if they'd been living when mine were required. I'm the brother of a laughing openhanded man with whom I've never exchanged an angry adult word nor wanted to. I'm the cousin of a woman who, with her husband, offered to see me through to the grave. I'm the neighbor of a couple who offered to share my life, however long I lasted. I'm the ward of a line of responsible assistants who've moved into my home and life at twelve-month intervals, taken charge of both the house and me and insured a safe and favorable atmosphere for ongoing work. I'm the friend of many more spacious and lively souls than I've earned. I've had, and still have, more love—in body and mind— than I dreamed of in my lone boyhood.

FROM *A Whole New Life*

. . . I believe that all works of art of all sizes—from the Parthenon to *King Lear* to the briefest Elizabethan lyric, the whisk in the Japanese tea ceremony—have kinetic intent. They came into existence in order to change something (or a number of things)—the actions of a friend, the hatred of an enemy, the savagery of man, the course of poetry, the sounds in the air. So—again—do all acts, maybe all atoms.

FROM "Dodging Apples"

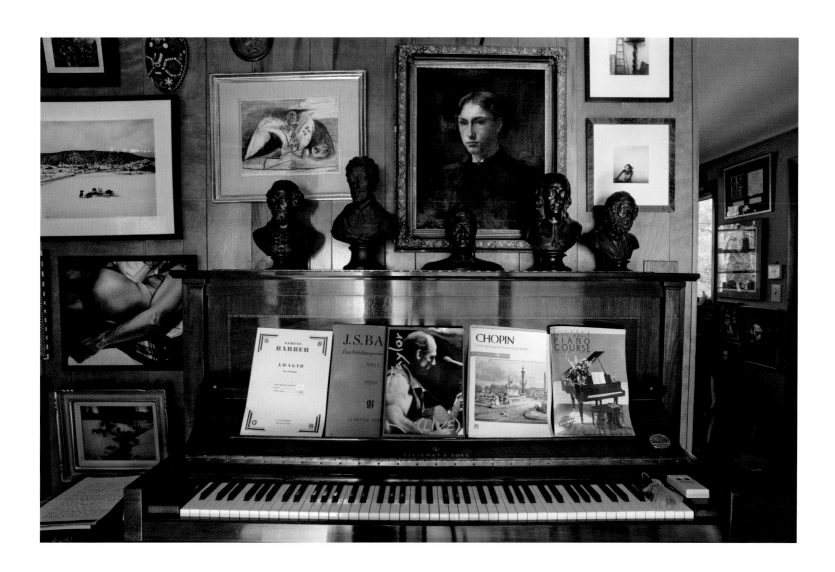

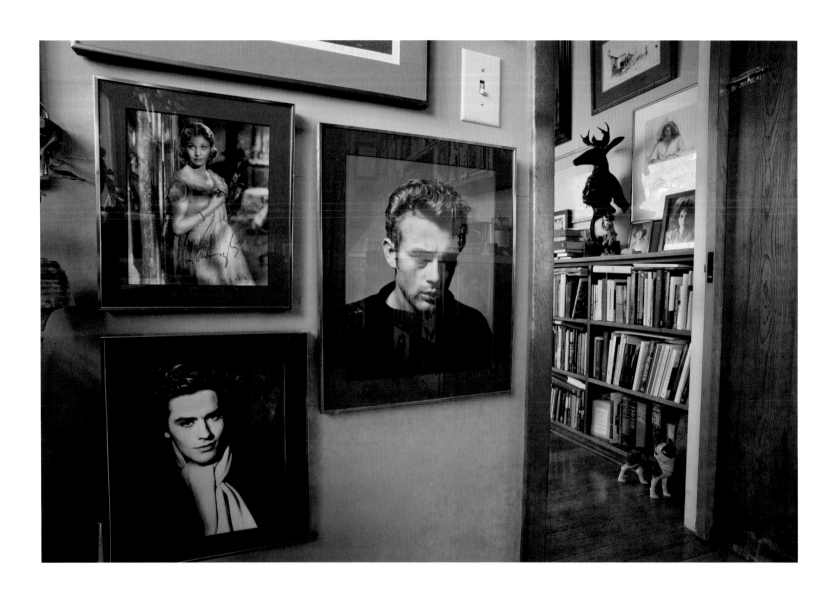

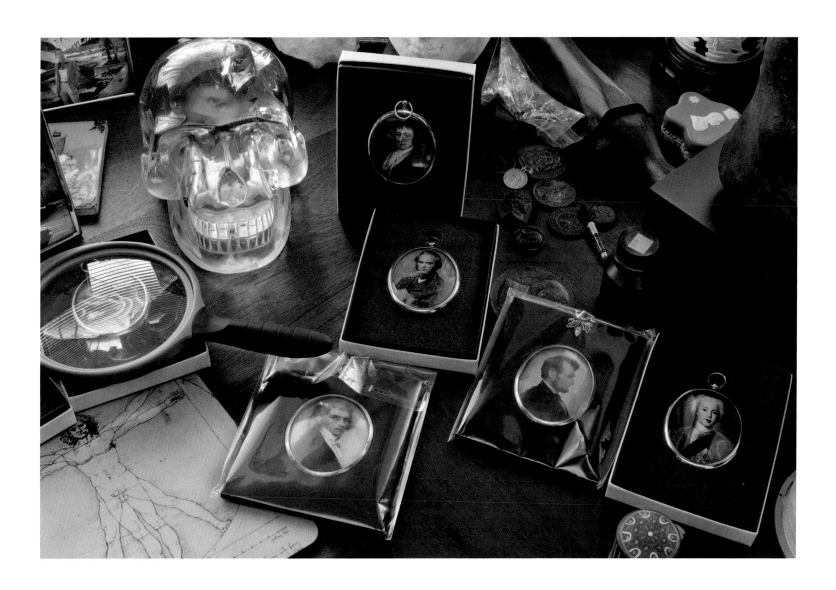

Heroes must be figures whom we feel to be unnaturally charged with some force we want but seem to lack—courage, craft, intelligence, stamina, beauty—and by imaginary contact with whom we experience a transfer of the force desired.

FROM "Available Heroes"

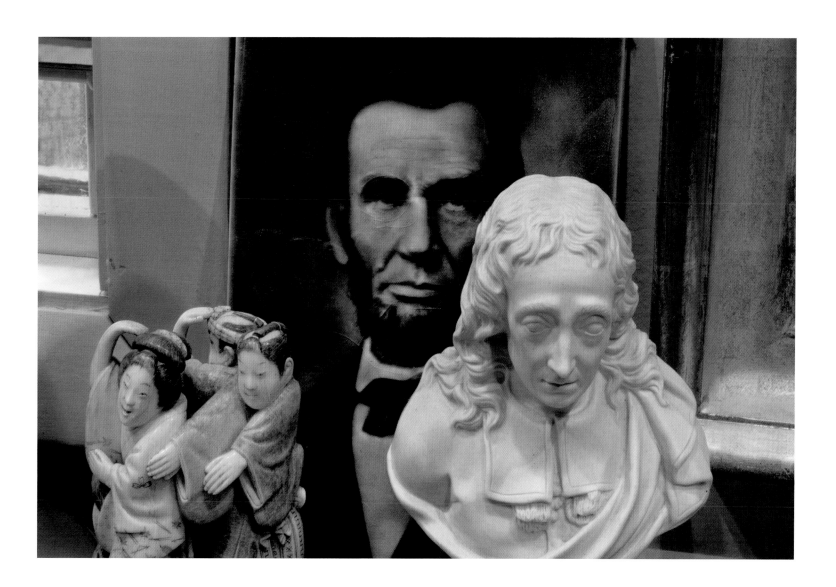

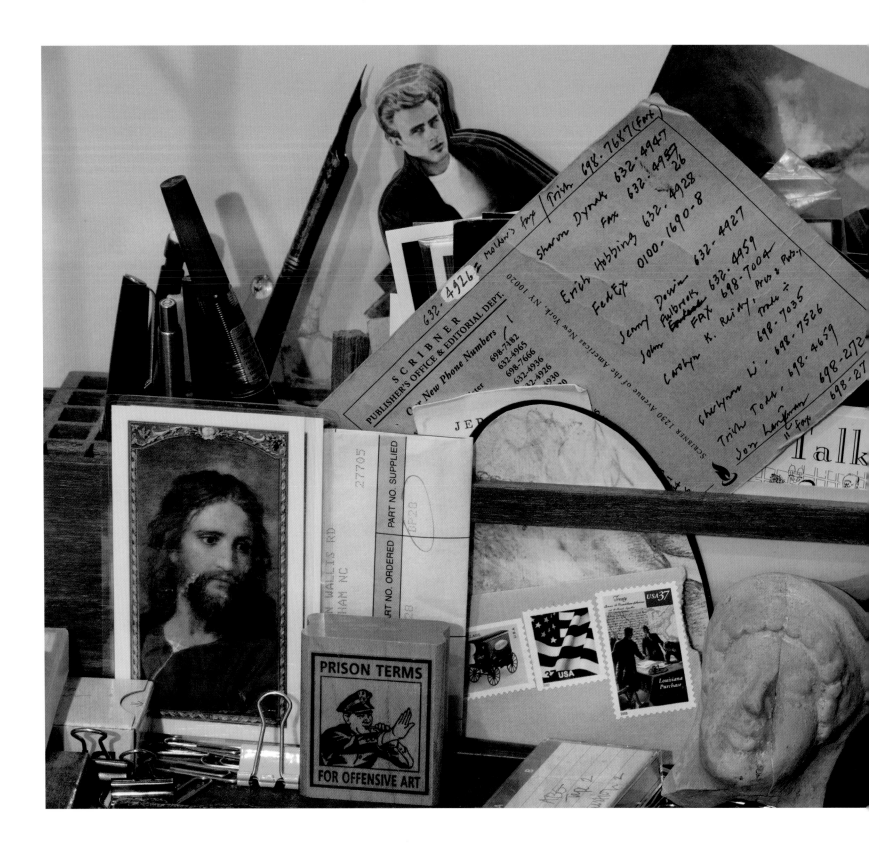

Prayer has always been a very important part of my daily life. It's so much part of my daily life I don't even think of it as prayer. It just seems like the same thing as making the coffee and answering the phone and doing the work. I don't have elaborate, ceremonial ways that I do it. I am not a churchgoing person. But I think I'm an intensely religious person.

FROM *The Writer's Faith: 2005 Calendar*

15 March 1987 (to W.S.P.)

Today I've lived my father's life—
Fifty-four years, forty-two days.

Father—there beyond that wall—
I beg to pass you, beg your plea

For excess life: more earthly luck
Or a longer sentence in the old appalling

Gorgeous jail in which you craved
My vivid mother, made my bones.

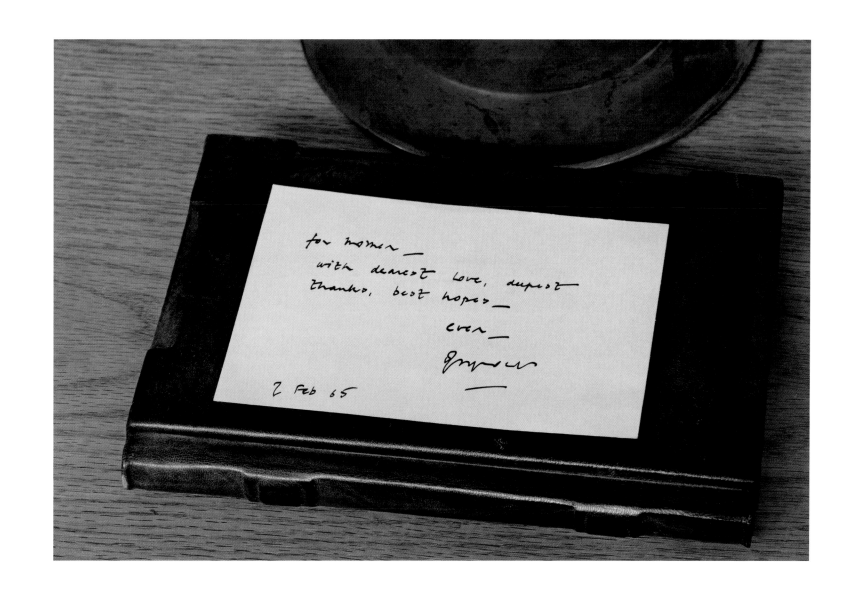

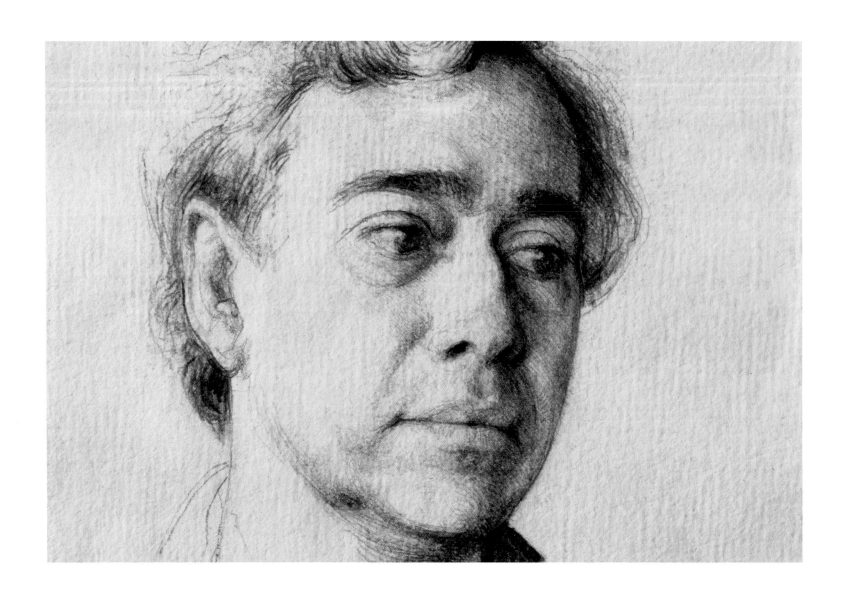

I here deny earth's riches last.
One thief of three will seize all men—
Plague, old age, hate—and only praise
From them who stay is fame past death,
Fame won in deeds from foes on earth,
Fiend in dark: fame among hosts of God,
Bright angels.

FROM "Seafarer"

We waded out into cool lake water twenty feet from shore till we stood waist-deep.

I was in my body but was also watching my body from slightly upward and behind. I could see the purple dye on my back, the long rectangle that boxed my thriving tumor.

Jesus silently took up handfuls of water and poured them over my head and back till water ran down my puckered scar. Then he spoke once—"Your sins are forgiven"—and turned to shore again, done with me.

I came on behind him, thinking in standard greedy fashion, *It's not my sins I'm worried about.* So to Jesus' receding back, I had the gall to say "Am I also cured?"

He turned to face me, no sign of a smile, and finally said two words— "That too." Then he climbed from the water, not looking round, really done with me.

I followed him out and then, with no palpable seam in the texture of time or place, I was home again in my wide bed.

FROM *A Whole New Life*

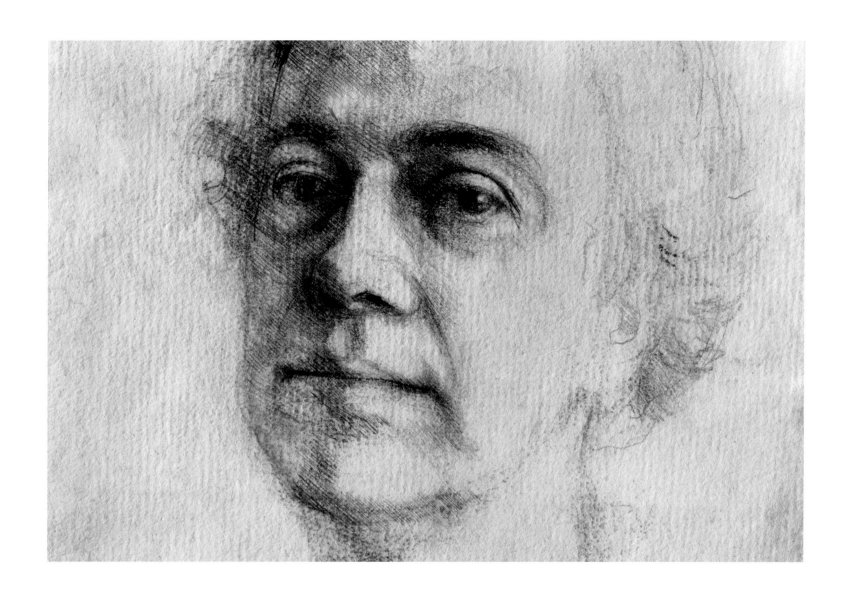

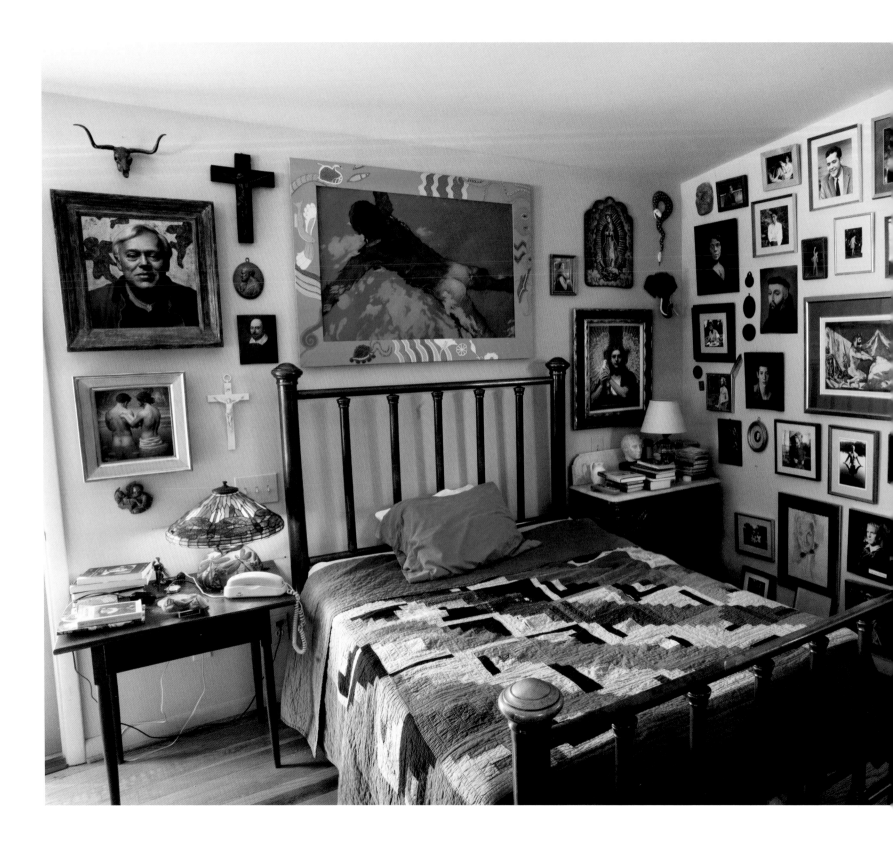

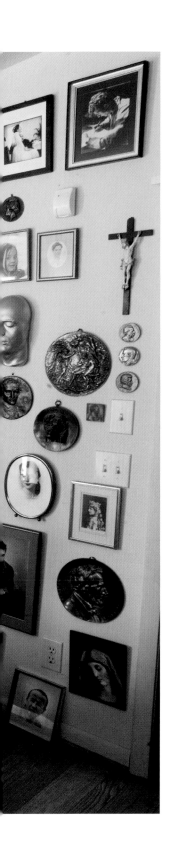

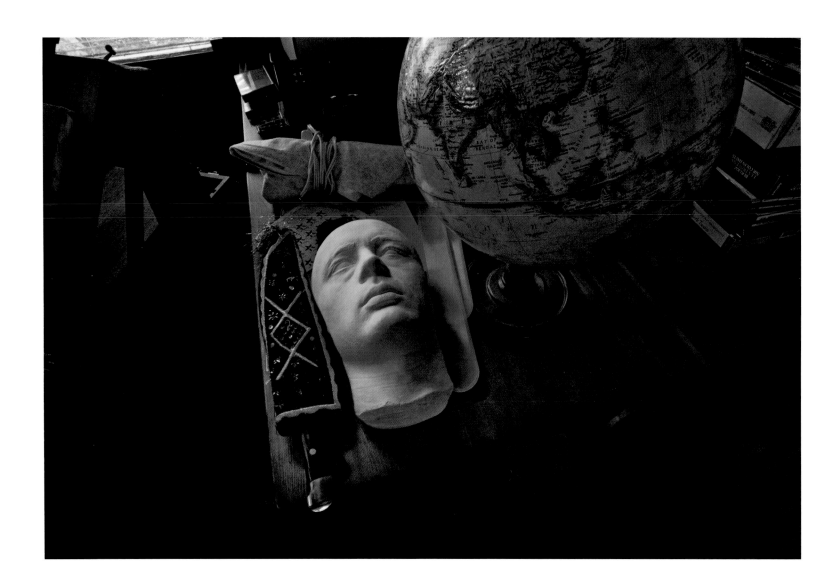

I think the laws of ice are those things which, at some point in all our lives, early or late, freeze us in a sudden random position—moral, physical, whatever. And we wind up being inexorably what we're going to be from then on. The Laws of Ice are the Laws of Death. They're the laws that are implicit in all of our physical and spiritual natures.

FROM *Conversations with Reynolds Price*

. . . how does a newborn child learn the three indispensable human skills he is born without? How does he learn to live, love, and die? How do we learn to depend emotionally and spiritually on others and to trust them with our lives? How do we learn the few but vital ways to honor other creatures and delight in their presence? And how do we learn to bear, use and transmit that knowledge through the span of a life and then to relinquish it?

FROM *Clear Pictures*

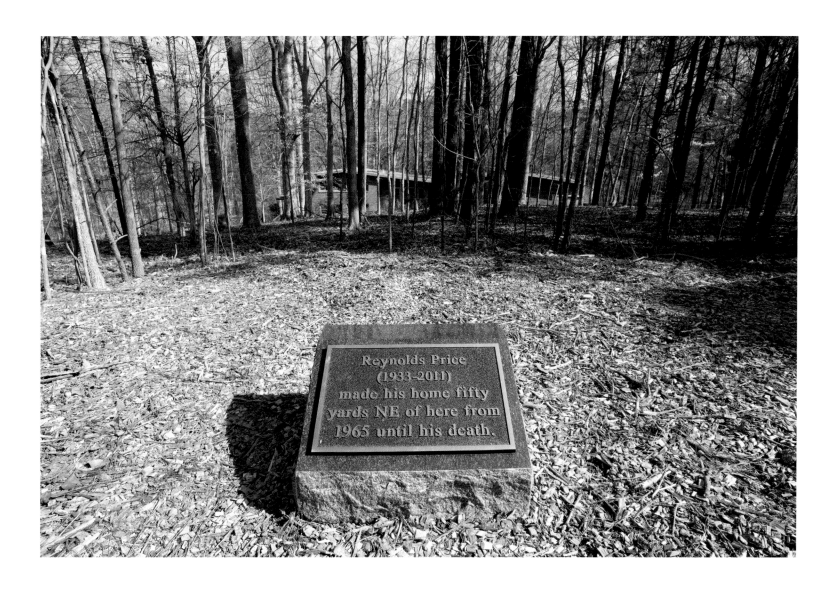

The Dream of Me Walking

In just the last month, three friends have said
"You walked upright in my dream last night."
Since in my own dreams I've never sat down,
I wonder whether they're being told something
I need to know.
 The chance of self-
Propelled locomotion is immensely unlikely,
But maybe the joined intensity
Of the three friends' dreaming will help me walk
Occasionally through my own sleep
Since—four or five years now—I've mainly flown:
My arms in broad slow condor sweeps
That never lift me high off ground
But never fail.

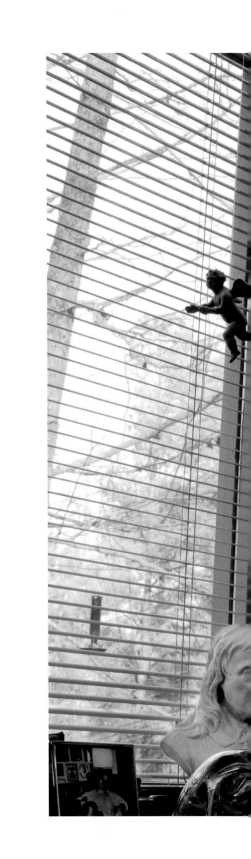

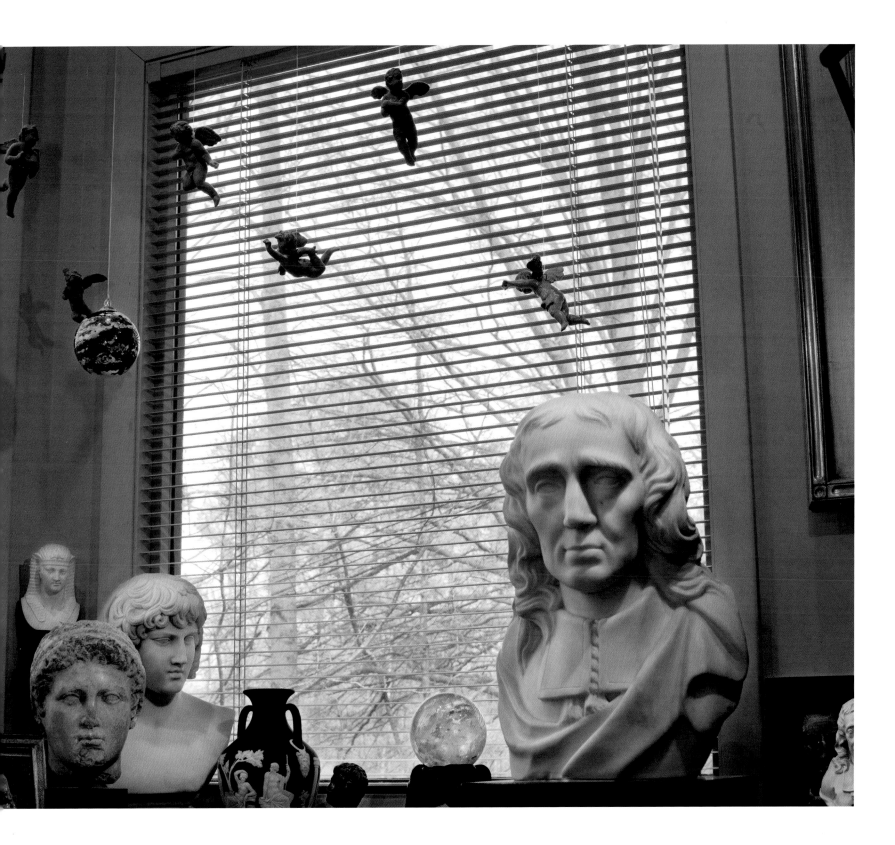

Farewell with Photographs

Time is mainly pictures,
After a while is only pictures.

Five years, for instance—all but two thousand days—
Will resolve to a few dozen pictures in time:
Of which, if ten give long-range pleasure to their veterans,
Thanks are due.

Thanks then for time—
Deep-cut pictures,
Mainly delight.

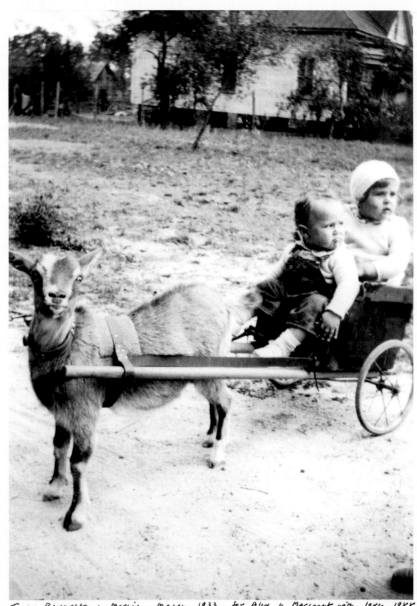

Topsy, Reynolds & Margie, Macon 1933 - for Alex & Margaret with love, 1988

Farewell with Photographs

It doesn't look easy sitting there on the edge of his hard seat. Reynolds should be warm enough on this Carolina winter day and used to occupying his perch by now. He is wearing loose-fitting overalls and a long-sleeved sweater. His white shoes look comfortable and new, so clean they may never before have touched the ground. But he is scowling, with his shoulders raised, eyes narrowed, and chin jutting forward.

Margaret and I have seen that look before. Rarely, but we have seen it. If Reynolds were stuck in an aggravating conversation—say, with an interviewer doubtful about his lifelong Christian beliefs—he would be polite. He wouldn't show anger. It was subtle, but we could see what he was feeling. He would raise his shoulders slightly and purse his lips. Once, sitting in Reynolds's living room, I began to tell him about a homeless man who had approached me that day on a street near the Duke University campus. Something in my voice must have hinted at disrespect. I caught myself in mid-sentence when I saw his expression.

When Reynolds Price gave us this scowling photograph in 1988, we paid little attention to the look on his face. The year is 1934, and Reynolds is just over one year old, seated in front of his cousin, Marcia, on a wooden cart about to be pulled by Topsy, the family goat, in harness. But we recognized right away that young Reynolds was sitting on what amounted to a movable chair with wheels beneath him. His arms, relaxed by his side, were in position to reach for those wheels and move himself forward. The picture was an eerily prophetic portrait of the then fifty-five-year-old man seated in our kitchen in his wheelchair.

The year is 1988, and the photograph will soon be published in *Clear Pictures* (1989), the first of Reynolds's four memoirs, a book that covers his life through his graduation from Duke up to the eve of his departure for Oxford University and a Rhodes Scholarship, the only significant stretch of time Reynolds spent away from North Carolina. That evening, he brought the picture, already signed, to our

house and seemed tremendously pleased with himself to be handing it over. We were pleased, too. Margaret has a collection of antique frames and found a perfect fit. Before dinner, as Reynolds watched, we hung his picture in the kitchen with the photographs of our immediate family.

Reynolds was in especially good spirits that night. It had been almost four years since he began to notice that his left leg lacked strength and that walking was becoming difficult. At Duke University Hospital, he was diagnosed with spinal cancer and received the radiation treatments that quickly rendered him a paraplegic and put him in a wheelchair. He spent three of those years on heavy doses of narcotics for the pain he once described to Margaret and me as a ten on the pain scale of one to ten. Some days he could only sit at his writing desk for three hours before taking to his bed. There, he listened to music by Mahler, Copeland, Callas, or his old friend, the diva Leontyne Price, and waited for his assistant to turn him every few hours. Yet in spite of all this, during those years, Reynolds completed the bulk of his novel *Kate Vaiden* (1986), which won a National Book Critics Circle Award. He also finished another novel, *Good Hearts* (1988), and published a play, *Private Contentment* (1984), a book of essays, *A Common Room* (1987), and a book of poetry, *The Laws of Ice* (1986), with the haunting title poem that predicts the inescapable, frozen moment that comes to all our lives.

It had been less than a year since Reynolds had discovered and mastered the bio-feedback and self-hypnosis that not only liberated him from constant awareness of his pain, but also freed up what Reynolds called the "great rooms of memory" that flowed into *Clear Pictures*. We marveled at Reynolds's heightened artistic energy and at the range of his creative gifts. Before his cancer, Reynolds described writing as "hard, very hard"; after his cancer, something shifted, eased. During the next three years, while teaching courses on Milton, creative writing, and the Christian gospels at Duke, Reynolds brought out works in practically every genre imaginable: another novel, a book of poems, a trilogy of plays, a collection of short stories, and two songs co-written with fellow North Carolinian James Taylor.

On more than one occasion after his cancer treatment and paralysis, as we sat with him in his living room in the evening over drinks, Reynolds said that he

was the happiest person he knew, maybe the luckiest, too. Margaret and I talked about how Reynolds enjoyed life—seemed more fully alive—maybe than anyone we had ever known. But you had to hear him say it to believe that the cancer he had suffered was a kind of gift that had made his life better.

Reynolds felt like family. Well, maybe not like my own family but more like Margaret's, the family I had married into. He and Margaret delighted in each other's company and had an affinity that was lovely to be around. They both grew up in small Southern towns, with a curiosity about the larger world and a passion for reading about that world. Reynolds managed to get permission to delve into the adult section of a municipal library by the time he was in second grade. By middle school, Margaret was sneaking into that roped-off area of her public library reserved for card-carrying citizens at least eighteen years of age.

Margaret grew up in northern Louisiana near the Arkansas border and Reynolds in a series of towns across the Piedmont of North Carolina, as his father tried to make a living as a salesman during the Great Depression. I grew up in suburban Jewish Atlanta with parents who, between them, were married seven times. To me, it seemed like a fairy tale when Reynolds said that if he and his younger brother, Bill, were emotionally handicapped later in life, it was because they seldom met people as affectionate with one another as their parents. In fact, both Margaret and Reynolds came from intact families with parents they loved and admired, along with unpretentious extended families and a wide range of neighbors and friends who were often around the house, telling stories, offering advice, gossiping, and laughing. As children they had each found religion, were more religious than their parents, and maintained their beliefs through adulthood, not in a church-going way but as something personal and deep. I think they also shared an almost old-fashioned expectation of the best from other people, while admitting that they were not exactly saints.

More than once we heard Reynolds tell the story of his note to Bill Clinton, who, during his first term, had invited Reynolds to the White House for dinner. In Clinton's second term, during the Monica Lewinsky impeachment hearings, Reynolds wrote the President a note that was one sentence long: "Dear Bill, I've done worse!"

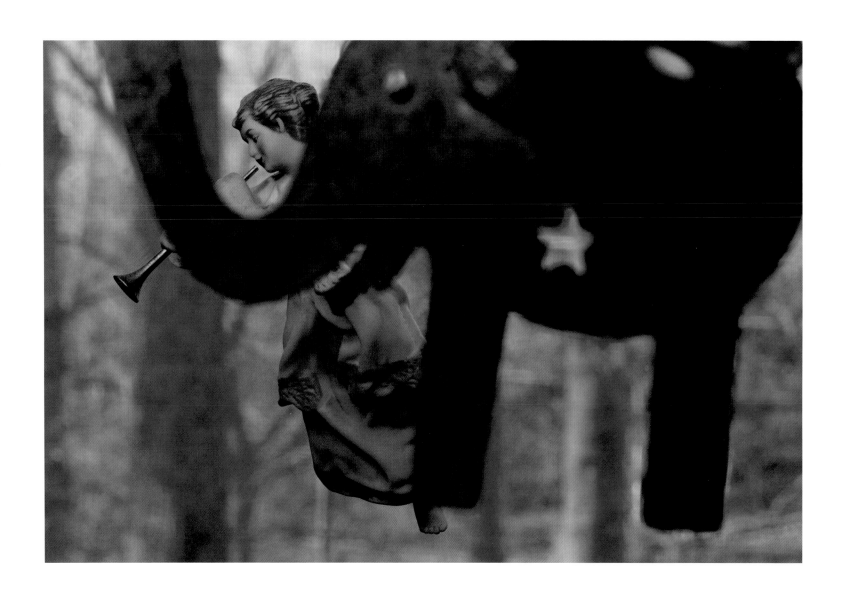

We sometimes caught glimpses of that other side of Reynolds. He could be disagreeable, especially if someone threatened his much-loved routine—every morning at his desk, eight months a year, six days a week, at least six hours a day, 300 words on paper—and the autonomy he needed for his work. We heard from other friends that, if they asked more from Reynolds than he was willing to give, he could be mean at times. We never experienced this side of Reynolds; the main thing we wanted from him was his company, outside of working hours.

If Reynolds was coming over, we would clean the house, light candles, set out our best china and glassware, and make a special meal. I was the cook. It was a ritual, a kind of tradition. He did the same when we visited him. When we arrived at his house, walked up the wheelchair ramp and through the glass door at the back, he would greet me with a kiss and "Hello, pal." Margaret would get a kiss and "Hello, darlin'."

With Reynolds we felt like ourselves, more at ease with him than with our other close friends. We could count on jokes and gossip. We talked about everything from a new painting he had acquired, friends we knew in common, books we were reading, the latest scandal in the news or trial on Court TV. Reynolds liked to share the covers and designs of his forthcoming books with us, which Atheneum, his publisher, gave him the unusual right to select or refuse. I especially remember his pleasure in the drawing he had arranged for the cover of his children's story, *A Perfect Friend* (2000), a tableau of an elephant and young boy in the jungle that was an original creation by his friend Maurice Sendak. Reynolds loved to talk about his childhood obsession with elephants, evidence of which we could still see in the small, elephantine replicas that marched across countertops of his house. We talked a lot about movies. He and Margaret had dueling encyclopedic memories of every actor or actress they had ever seen on the screen. And there was Reynolds's fascination with Demi Moore's rumored liposuction or Michael Jackson's latest nose. I earned a lot of street cred with Reynolds when my brother covered the O. J. Simpson trial for CNN. But if we shared something private or told Reynolds a secret, we did so knowing he would likely divulge it to another friend by the next day.

Reynolds was an entertainer, and, like many stand-up comics, the leading man in the stories he told was, usually, delightfully, Reynolds Price. Whether you

were sitting with Reynolds alone in his home or talking with him at a crowded reception, he focused his attention on you in a way that few people I have encountered are able to do. You knew with absolute certainty that Reynolds was looking at you, took pleasure in being with you, and, with his extraordinary baritone voice, was talking to no one but you. Margaret wouldn't want me to write this, but, in her own way, she is like that, too, and though it exhausts her at times, I think people are drawn to her for similar reasons.

What I am getting at is that Reynolds—as is true of Margaret—managed to be his best self in the way he connected with people he encountered. If I am my best self, fully present and engaged, it is in my photographs. You catch glimpses of that person behind the camera in my portraits, reflected in the faces of people from other cultures and even in the faces of my own family, as they gaze back at me. It is as if I am looking into the lives of others for what is worth preserving and recording, creating in my photographs a permanent, intact home where we might all want to return.

In his Durham, North Carolina, home, the modest deckhouse he purchased in 1965—a brick-and-wood structure set within a pine and hardwood forest and perched above a small pond that a great blue heron visited annually around Christmas—Reynolds Price lived in a state he, at times, called "chosen singleness" and, on other occasions, "a much befriended solitude." Reynolds never married or had a long-term partner, though he was assisted each year of his last twenty-five years by a different live-in Duke graduate, often an ex-student from one of his seminars. He wrote about love in many forms but didn't discuss his own homosexuality publicly until after his memoir *Ardent Spirits* (2009) was published. Reynolds told Margaret and me that there were, at most, two marriages he had witnessed in his life that he truly envied. I sometimes wondered if Reynolds genuinely believed this or if he was just convincing himself that living alone was preferable to conjugal life. So many of the characters whose lives unfold on the pages of Reynolds's novels and stories struggle with the tension between a desire for love and companionship and the autonomy of an independent existence. Though Reynolds proclaimed he craved his solitude "like a deer craves salt licks," it is not a stretch to imagine him torn at times between these two ways of living.

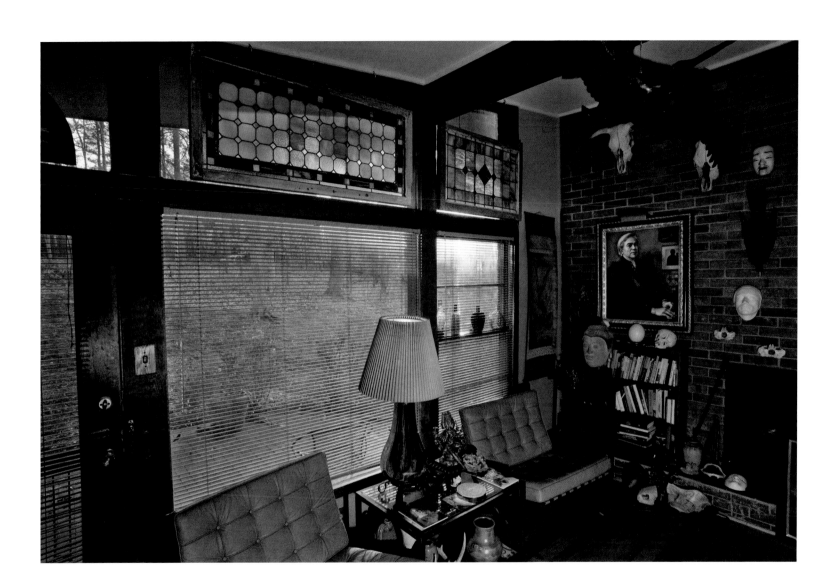

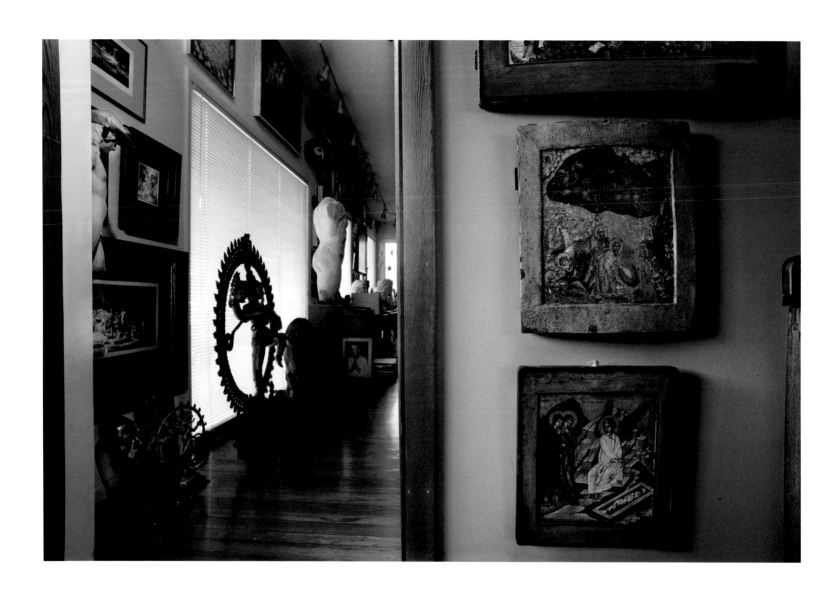

I write that previous sentence not to provide psychological analysis of my old friend but to try to understand better the actual subject of this book: Reynolds Price's home, the world he created for himself through the photographs, paintings, statues, and objects he collected and arranged, his constant companions in a solitary life.

This book began as a dream. Actually, two dreams. I woke up early one July morning in 2011, with Margaret sleeping next to me, six months after Reynolds died. Still groggy, I had a vivid memory of being with him. In my dream, he was standing, lost in thought, in the doorway of a restaurant's dining room. I was seated at a table inside a large dining area, surrounded by other patrons at other tables, when I looked up and saw him. Somehow it didn't surprise me that Reynolds was standing or that he was younger and slimmer than when I had last visited him. He was maybe fifteen years younger and around fifty pounds lighter. His hair had not yet turned fully white. Nor did it surprise me to see him the next moment in his wheelchair, rolling past me and out the room. Though in the dream I knew I hadn't seen Reynolds in many months, he barely acknowledged me when he glanced my way.

I stood and followed and found him sitting in the dark in another, much smaller room. He sat alone at a small round table in the otherwise deserted space. He wore a pair of cheap reading glasses with pliable gold-metal frames and plastic lenses, like the kind you can buy at Walmart. On his table there were two candles and some matches. As I lit the candles, Reynolds became agitated. He moved his hands to his forehead like a man who is annoyed or deep in thought. I worried that, by lighting the candles, I had somehow disturbed him. Reynolds took off his glasses. Holding them in front of his eyes as if for inspection, he finally spoke: "My glasses aren't working; they aren't helping me to see."

As I lay in bed thinking about my dream, Margaret stirred. I told her, "I had a dream about Reynolds." She replied, "That's strange, I had a dream about Reynolds, too, but if you hadn't mentioned it, I wouldn't have remembered." Before I could speak again, she said, "In my dream, I was watching Reynolds cross a street.

He was in his wheelchair and having difficulty navigating the intersection, even though he was in a clearly marked crosswalk. Reynolds must have been fifty pounds lighter, and his hair was gray with dark streaks. It wasn't white. It was very silky. He was much younger than when I last saw him. He looked good but seemed agitated." Margaret continued, "After Reynolds crossed the street, he encountered a friend. Reynolds had on a pair of aviator glasses, and I heard the friend say to him, "I thought it was strange that you were wearing glasses, because you are blind. But it's not strange, because I guess you've always worn glasses.""

When I told Margaret my dream, we were both stunned. Though we had shared our dreams for years, we had never dreamt about the same person or had dreams on the same night with even remotely converging plot lines. In the plot lines of Reynolds's short stories and novels, he often gave his own dreams to his characters. When he was writing, Reynolds would so fully inhabit his character's thoughts, emotions, and actions; he believed that—asleep at night—he was dreaming their dreams. But neither Margaret nor I had been actively thinking about Reynolds, nor had we driven by his home, only a few miles from ours. There had been no fresh reminders of Reynolds on Duke's campus, where he taught for more than fifty years and where we were still teaching. In fact, Margaret and I woke up that morning in the mountains of northern New Mexico, nearly 2,000 miles away from Durham, where we had been friends with Reynolds for three decades.

But, then, Reynolds knew how to find us. Once, on a summer trip out West, he had driven from Santa Fe up the steep, paved High Road to Taos, which winds through a number of tiny Hispanic villages, the same route taken by the seventeenth- and eighteenth-century descendants of Spanish explorers when founding these adobe settlements. An hour later, he turned onto a U.S. Forest Service dirt road, drove through two miles of ponderosa pine forest, then, just past the village's graveyard, turned onto our steep, rutted driveway and maneuvered another quarter-mile to our second home in New Mexico.

In our dreams, it felt as if Reynolds had found us again, felt much more like a purposeful visit from Reynolds himself—or his spirit—than Freud's dreamwork to be analyzed for hidden symbols or repressed meanings. Margaret and I didn't

know how to explain our concurrent dreams other than to be reminded that, for Reynolds Price, seeing was everything.

On more than one evening in conversation with Reynolds in his living room or at our kitchen table, we had shared our earliest memories. I remembered that, when I was four years old in Atlanta, I saw my younger sister fall down an outdoor flight of stone stairs and my parents' panicked reaction. Margaret's first memory was from earlier—before she was the age of three—of seeing her mother seated in a chair in their Louisiana living room and reaching down to pick up her crawling younger brother who had usurped her place as the baby in the family. Never one to be outdone, Reynolds remembered when, at four or five months old and lying on a white blanket under a blue sky and laughing for the first time, Topsy, the family goat, licked his forehead and began to nibble at his clothes. But his earliest memory was of pale, rose sunlight glowing through his mother Elizabeth's skin to his embryonic eyes.

The act of seeing was at the very heart of the language of the old, traditional South as spoken by Elizabeth, by Reynolds's father, Will, and by their relatives and friends. Of his childhood Reynolds wrote, "I was mesmerized by the visible world as deeply as any snake-spied bird." Will taught Reynolds to draw elephants, and, by the age of three or four, he had created his own parades of them on the yellow pads Will brought home from the office. Through much of his North Carolina childhood and adolescence—before he turned seriously to writing as a senior at Broughton High School in Raleigh and as an undergraduate at Duke— Reynolds pursued drawing and painting with fervor, making careful copies of the faces of ancient heroes from his favorite books, later sketching modern faces from *Life* and *Look* magazines. He continued to draw throughout his life, and drawing may have saved his life. During the first five months after his surgery, when he couldn't write and could barely focus enough to read, Reynolds drew the face of Jesus over and over again and rendered a vision of Jesus healing him from cancer. The drawings filled six spiral notebooks.

Reynolds said that, for him, writing began with a visual experience. Each short story, novel, play, or poem started with a single scene—a brief, imagined

film clip unspooling through projector light and developing into a story on the screen of his brain. That unfolding scene often began years before he started to write, with an object or image Reynolds was drawn to and had collected and carefully placed in his home.

On a visit to the Rijksmuseum in The Hague, for example, Reynolds was captivated by Vermeer's *Woman in Blue Reading a Letter* (ca. 1663). He purchased and framed a faithful reproduction, which he leaned against the wall next to his work table at home. In the painting, a young, pregnant woman in a blue smock stands reading a letter in the light from a nearby window. Within two years of seeing *Woman in Blue*, Reynolds began his first and much-acclaimed novel, *A Long and Happy Life* (1962), by writing a scene in which Rosacoke Mustian, a young, pregnant woman, reads a letter from her distant lover, Wesley Beavers. And there was a postcard of the head of Pharaoh Akhenaten, which Reynolds purchased while he was at Oxford during the late 1950s, that so reminded him of an old, itinerant African-American man named Grant, his close companion from childhood, that it inspired his short story "Uncle Grant" (1963). Reynolds also hung a portrait of Confederate General Robert E. Lee, photographed a week before Lee died, almost at floor level in his office, where he could see it every time he rolled by. Lee's portrait made Reynolds think of King Lear and stimulated both a dream and the long poem "The Dream of Lee" (1999). From the audacious first sentence of *A Long and Happy Life* (1962) through twelve other novels, a children's book, dozens of short stories, essays, poems, epistles, fifty-two radio commentaries broadcast on National Public Radio, an apocryphal gospel, translations of the Gospels of Mark and John from the original Greek, and three memoirs with a fourth, *Midstream,* half-finished at his death—forty-one books in all—Reynolds drew inspiration from his collections and rendered with keenness and clarity his visual experience of life.

Friends who visited Reynolds at his home in Durham knew about the distinctive visual world he created there. Though his collections had begun long before, when Reynolds became a relative shut-in after he was confined to a wheelchair in 1984, his rooms gradually filled floor to ceiling with his passions

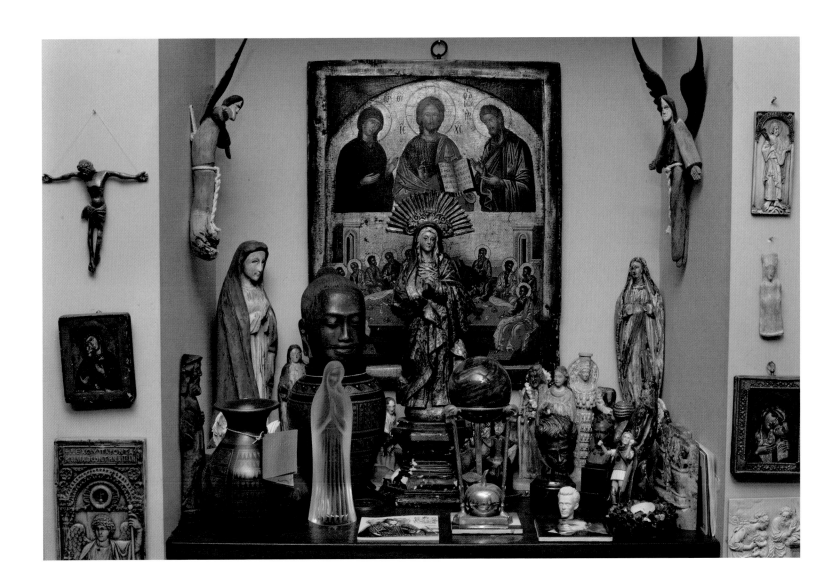

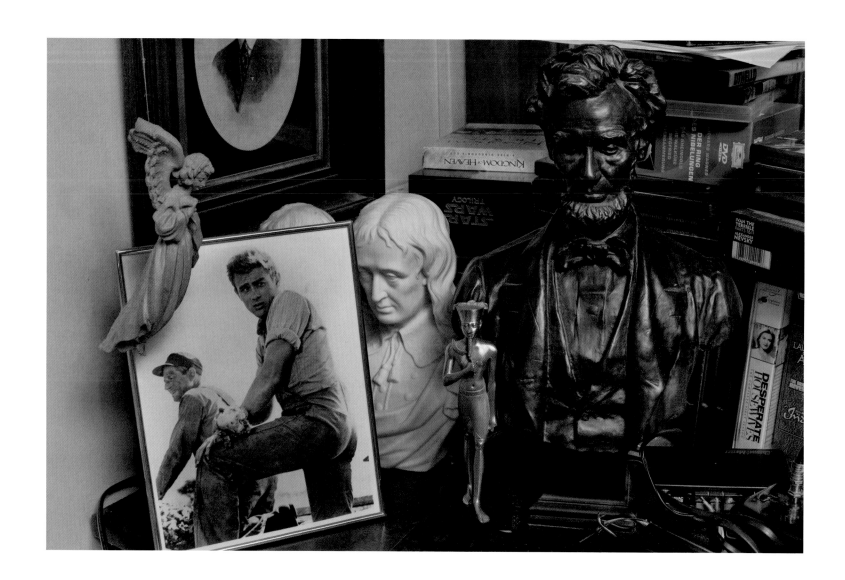

and preoccupations: books, including a closed bookcase of his own first editions arranged in chronological order; paintings, particularly the landscapes of North Carolina and the South that provided the settings for his novels and stories; a number of sketches and formal oil portraits of Reynolds himself; etchings from Blake and two of Abraham and Issac by Rembrandt, each Rembrandt inspiring an essay; Greek marble busts and sculptures; wooden, ceramic, and plaster masks from many cultures, including death masks of John Keats, William Blake, and Marlon Brando; a large collection of photographs, including two photographs printed as gifts by and from Margaret and two from me; numerous icons; and a wide variety of items, from a saber-toothed tiger's skull to multiple copies of Dante's *Divine Comedy*, which Reynolds collected, purchased, or was given over the years.

Margaret and I are both photographers, and she shared with Reynolds a preoccupation with collecting. I had studied photography at Yale University with Walker Evans, whose Connecticut home contained his own collections of paintings, photographs, old signs, and objects such as sharks' teeth or discarded pop-tops he used in his collages. Walker believed that the impulse to collect, compile, and arrange images is at the heart of photography. And, in that sense, I am a collector, too. Certainly, Margaret and I notice the way things look or are arranged. We always commented to Reynolds, when he purchased a painting or sculpture or moved an object in his house or added a portrait to his bedroom's wall of heroes—an arrangement of photographs of close friends and relatives, some dead before he was born—the essential audience for whom Reynolds said he wrote.

Though Reynolds did not belong to a congregation or attend church regularly, he was a religious man who, in one house for more than four decades, created his own hallowed space. Jesus was the most ubiquitous character, appearing in many forms, from Reynolds's own drawings or the drawings and paintings of other artists to retablos, to ancient and contemporary icons, crosses, and statues. Busts of Buddha in several styles and poses could be found around the home along with a variety of Hindu deities, and there were eclectic altars upon which Reynolds united the gods of other religions and cultures with numerous Madonnas and paintings of the Last Supper and angels.

Dozens of angels hung from the ceiling of his kitchen and office, an assortment ranging from a winged Miss Piggy in plastic to a classically sculpted, golden Gabriel. Since childhood, with practically religious devotion, Reynolds had also collected portraits of certain movie stars, among them Sir Laurence Olivier, Gregory Peck, Audrey Hepburn, and, especially, James Dean. Their faces covered one wall of kitchen cabinets, a gathering of secular icons that pointed to the possibility of living an inspired, heroic life. Around the house you could find multiple drawings and busts of other heroes—Milton, Shakespeare, Lincoln, and Robert Kennedy—and statues close by of composers Chopin, Haydn, and Mozart, which he began amassing as early as the sixth grade. Among the dozens of framed photographs of family and friends, several people turned up repeatedly: his younger brother, Bill, and Bill's wife, Pia, the writer and photographer Eudora Welty, his good friend and fellow North Carolinian James Taylor, and Daniel Voll.

Daniel, a former student at Duke, was as close to a son as Reynolds had on this planet. In 1984, shortly after Reynolds learned that his cancer and the radiation treatments would render him paraplegic, Daniel dropped a research and writing assignment in South Africa and moved in with Reynolds for a year, setting the stage for the assistants who would follow and—with the help of Bill and Pia Price and a close neighbor Jeff Anderson, who renovated his house to be accessible by wheelchair—made possible what Reynolds called *A Whole New Life* (1994), the title of his second memoir.

In one memorable portrait, young Daniel lies on Reynolds's brick patio, staring with calm amusement at a snake, an arm's-length away, coiled like a knotted shoelace between an aluminum chaise lounge and a metal table. That picture occupied a space on the counter across from the stove in Reynolds's kitchen, right next to a wood- and metal-framed snapshot of young Reynolds at Oxford University as a Rhodes Scholar, standing with ease and pleasure beside his housemate, Michael Jordan, his most loyal and treasured friend over a lifetime. In fact, when I photographed that countertop, I found Daniel's portrait leaning against the one of Reynolds and Michael Jordan as young men. My photograph reveals where Reynolds had placed himself, sandwiched close between his two best friends.

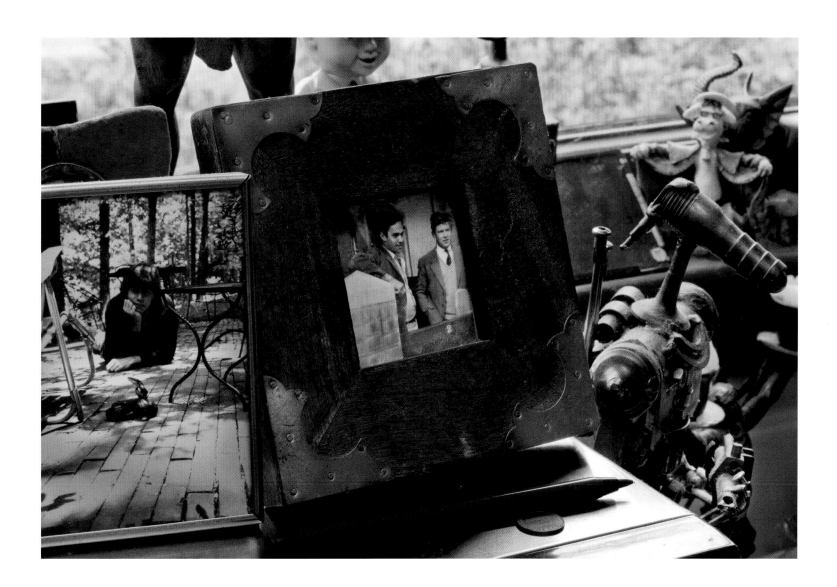

If this book were a film, Daniel Voll would be credited as the producer. Daniel, in fact, *is* a Hollywood producer and writer who knows how to make productions happen. As Daniel and Margaret walked through Reynolds's house less than a week after he had died, almost everything Reynolds had collected and carefully installed around the house was still in its place. They felt his presence strongly. Daniel suggested to Margaret that I photograph Reynolds's home. If I could get started soon, I would have time to photograph extensively before the house was dismantled. Later by phone, Daniel invited me to take on this project and then cleared the idea with Bill Price, Reynold's brother. By the time Bill and I spoke, we were each convinced that the project was our own idea, something we had dreamed up with Daniel Voll.

Maybe a Martian would consider an Earthling's demeanor as simply one of many equally important elements to ponder in a photograph, but, for those of us inhabiting this planet, an individual's face and bearing govern a picture's meaning. As a matter of survival, we are drawn to faces, hard-wired to recognize the distinctions between the nuances of hundreds of expressions and gestures—in the blink of an eye. The extraordinary capacity of the camera's shutter to freeze an eyelid in motion also freezes the meaning of a picture through the look on a face. In a portrait without people, many interpretations are possible. We are not so much told stories as we are drawn—from the evidence before us—to create our own. Without a person in the frame, we try to make sense of the mystery of a place or the accumulations of a lifetime.

When I showed up with my camera at Reynolds's home in February 2011—he died on January 20—I felt as if I had been training for this moment my entire working life. For more than forty years, in locations as disparate as the American South, Inuit villages in Alaska, the streets of Havana, and Hispanic towns in northern New Mexico, I learned to make portraits without the actual presence of people. In New Mexico, for instance, after more than a decade, I began to focus my camera on what literally had been the background in my earlier portraits of people there: the rooms, cars, and possessions people had occupied, used, or collected; the land they cleared, fenced, and farmed over generations.

I recall my first year in New Mexico. As I walked around the New Mexican village of Peñasco, I saw an old couple standing in their orchard and introduced myself. Their names were Celina and Pedro Cruz. Though I had recently rented a house in the same village and we knew neighbors in common, we had never met. That same morning I photographed Pedro standing under an apple tree and Celina leaning against her kitchen table: two portraits representing a moment in each of their lives. In 1986, I photographed that same kitchen table again, along with its two, aged aluminum chairs. I could see where the legs of those chairs had scraped the blue linoleum, in one place down to bare wood, a record of their daily movements as a couple, as they sat together and moved apart—a portrait not of a moment but of a marriage.

During the winter and early spring of 2011, I completed more than 700 photographs of Reynolds Price's home. Reynolds arranged his art in a salon style, a floor-to-ceiling display of works that originated in seventeenth-century exhibitions at the French Royal Academy and later migrated to the Louvre. I could not imagine a French curator of that era working with more disparate kinds of art than Reynolds had in his North Carolina home or taking more meticulous care than Reynolds did to place works precisely where they would resonate with other pieces, where he wanted them to live.

I began by taking pictures of the living room wall I was most familiar with (page 17). On that wall, next to white ceramic replicas of the mouth and foot of Michelangelo's David, a portrait of Emily Dickinson as a young woman, an oil painting of John Milton at the age of ten, another oil painting of a reclining male nude, an African mask, a bust of Shakespeare, and numerous other paintings and objects, Reynolds hung a series of oil-painted landscapes depicting coastal South Carolina, western North Carolina, New Mexico, Maine, and Wales. Reynolds had earned his nickname "the great indoorsman" by experiencing these quintessential views of nature through his windows and on this and other walls of his house.

In his living room, Margaret and I could see these landscapes directly across from where we sat in two orange-velvet upholstered club chairs and, in later years, in two tan leather Barcelona chairs. But on an actual visit we would have

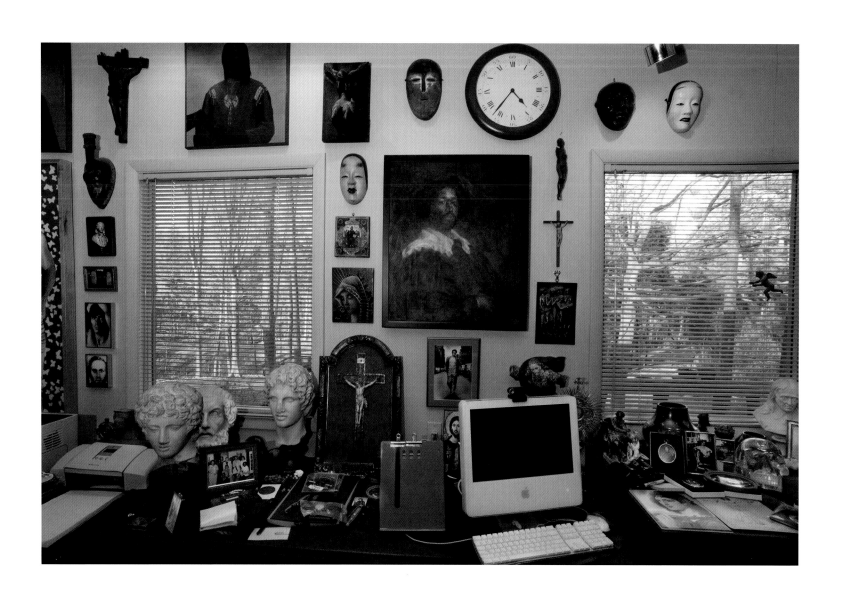

been paying attention to Reynolds seated in his wheelchair in front of the piano slightly to our right, turning our heads toward him in conversation. This wall was the background of our peripheral vision. Only Kartikeya, the golden, many-headed Hindu God on the glass table between Margaret and me (page 134), could have focused on Reynolds and, at the same time, appreciated all the works of art on the wall and in this room.

Alone in Reynolds's rooms, I knew my job was to focus. I set out to photograph every wall in every room and to take several views from different perspectives of each room Reynolds inhabited. I saw no reason to document the parts of the house upstairs and downstairs that Reynolds no longer visited in his wheelchair. I knew my photographs of Reynolds's home would be preserved alongside his papers at Duke University's David M. Rubenstein Rare Book and Manuscript Library, where almost 200 linear feet of his manuscripts, correspondence, speeches, interviews, notes, and other papers—96,900 items in all—are stored for posterity. With this in mind, I worked at first like a photographic archivist with a responsibility to preserve and record Reynolds's home as precisely and accurately as I could, to provide other perspectives from which to view his life and work.

As I made these broad views around Reynolds's house, the individual paintings, sculptures, and photographs I had always thought of as beautiful objects to be admired began to take on a new quality, to seem more luminous and real. It wasn't as if the masks, sculptures, and icons actually came alive—say, like Woody and Buzz Lightyear in *Toy Story*—but I began to feel that each work of art projected its distinct presence into the room. I was drawn to move in closer with my camera, to photograph these objects one at a time or in the small groupings Reynolds had arranged.

Near Reynolds's writing desk (opposite), I photographed three ancient busts of Apollo, Alexander the Great, and Homer. In front of their marble likenesses, Reynolds had placed a framed color snapshot of himself with a Raleigh book club. In the picture, Reynolds beams after his reading, surrounded by an equally pleased group of African-American women. But when you look closely, you can see that each woman has her own way of smiling and expressing her pleasure in the moment. Each statue also communicated its own complex emotions. Like marble

avatars with multiple personalities, each radiated the artistic vision and intention of the sculptor, conveyed the story of the god or individual they portrayed, and emanated some deep aspect of Reynolds himself, the part of him that was drawn to that sculpture, that expression, that ancient god or historical figure.

A carved stone head of Buddha, a haunting photographic portrait of Abraham Lincoln, a collection of Japanese-painted, wooden drama masks, and several oil and graphite portraits of Reynolds himself by Will Wilson and Ben Long each required an individual photograph. I purchased a longer lens, a sturdier tripod, and a remote shutter release in the hope of capturing new views and details of these works of art, of telling stories and making connections I had not seen before. Through my new lens, I could see a red-haired porcelain angel with a golden trumpet floating just above the curved green tusk of a smiling tin elephant—both angel and elephant set against the waning light of a North Carolina winter day.

As a photographer, I knew from experience that an emotional breakthrough in a portrait session can sometimes be achieved by moving in closer to a person, nearer than we would comfortably stand if we were simply speaking to one another. I looked again at the portrait paintings and drawings of Reynolds around the house and photographed them not as exact copies of the surface of the original works but as details, cropped, as I would have made a portrait of the man himself. I began to frame the books on Reynolds's shelves as I might see the edge of a North Carolina hardwood forest from the perspective of a hill just across a small valley—a thicket of multiple spines proclaiming *A Long and Happy Life* in English, French, Norwegian, and Spanish. The individual titles and fragments of the titles that Reynolds chose for his own book spines commanded special attention, like essential, found poetry from an inscrutable, born-again sage:

Permanent . . . Generous . . . Heart.
A Palpable God . . . Source of Light . . . Promise of Rest.
Love and Work . . . Early Dark . . . A Whole New Life.

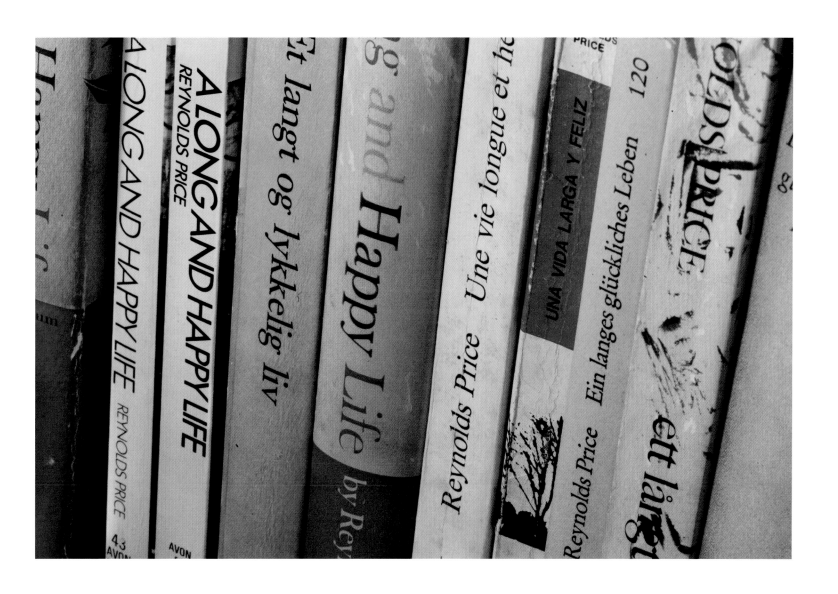

I made the last photographs of Reynolds Price's house in the spring of 2011 and selected what I considered the most comprehensive views and best images for his archive at Duke. On my computer, I adjusted the pictures for color and light to be true to the feeling of being in his rooms and chose the archival paper on which I would make my prints for the library. But until that summer, on the morning of our shared dreams, neither Margaret nor I had thought to do the one thing that Reynolds Price had been doing for his whole working life: to connect his *seeing* to his *words*.

We looked again at the photographs I had taken and made a new selection for what might become a book. We spent the better part of the next academic year and summer reading Reynolds's interviews, novels, notebooks, essays, short stories, and poems. We read for passages that linked Reynolds's collections and his writing, for connections between the visible world Reynolds had constructed in his house and the creations of his mind. Those connections became this book.

As we paired Reynolds's words with my photographs and began to sequence and then turn our newly assembled pages, it seemed as if Reynolds himself was taking us on a personal tour of his home. He was walking us through his rooms, pointing out particular pieces, revealing his thoughts, recounting important episodes in his life, and speaking about the people, ideas, and beliefs most important to him. Now, as we turn the pages of this actual book and look at the things that most inspired Reynolds in life, he can still weave stories for our edification and, more importantly, our pleasure.

There is one more story Reynolds Price told that bears repeating here. It is a story he divulged to the nation, broadcast in 1996 as the last of his fifty-two on-air essays for National Public Radio. As he explained, two years after his initial diagnosis of cancer and his first major surgery, Reynolds could no longer understand his own voice. His cancer had recurred near the base of his skull and was causing him scrambled thoughts and intense pain. As he was carried outside on a stretcher past a crew of carpenters working on a wheelchair-accessible annex to his house, it struck Reynolds that he might never return home to enjoy the

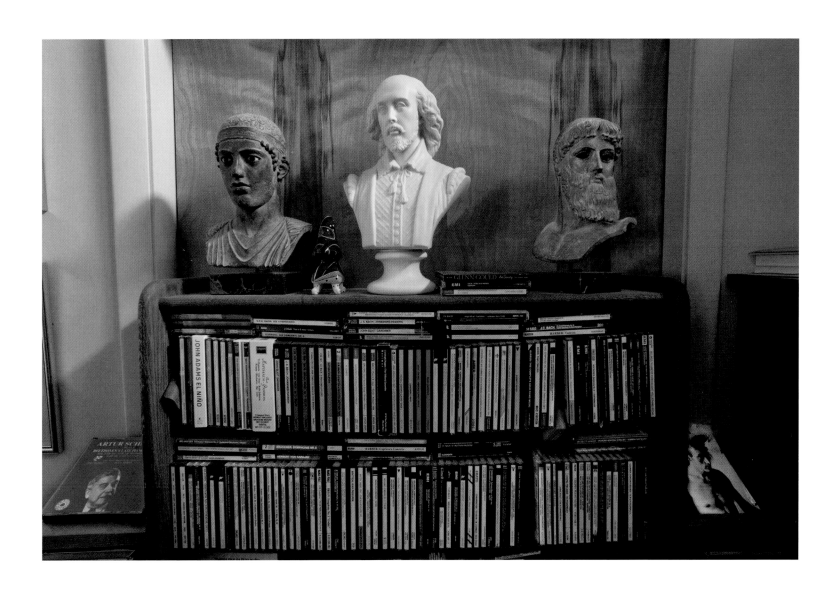

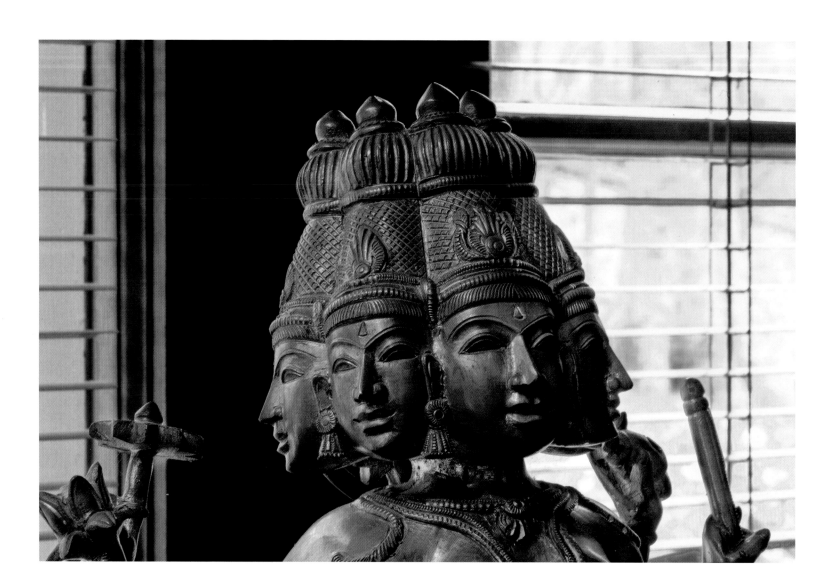

beautiful new addition. Until that moment, he had not allowed himself to think of what else he would be leaving if he did not survive.

Reynolds remembered thinking about the beautiful natural setting of his home, about his friends, about what must be millions of stored memories, about everything he had collected and treasured. Suddenly and with relief, Reynolds realized he could leave it all, "as stripped of earthly cares as a Buddhist monk in his final breath." Reynolds survived. Fourteen years later, as he told the story for NPR:

> The house seems healthy, its contents have grown and still delight me.
> But I doubt that they—and all my surroundings—know how I learned
> (in a wrongly hopeless moment), and have never mislaid, a true secret
> of inestimable worth: I can leave for good, with considerable ease, when
> that day dawns, which I hope is not soon.

Reynolds did not say that day on air why he realized he could leave this life with such equanimity. Those of us with children might have consolation in the thoughts of our offspring carrying on our memory. Reynolds had no children, but he had thousands of students he taught in their youth to see and many close friends to remember him. And Reynolds also has descendants, the satisfaction of his most important legacy: the volumes of fiction, poetry, essays, and plays that, unlike children and unlike everything he collected and cherished, remain precisely as he created them for all time.

ALEX HARRIS

Thanks

This fabulous loneliness dense as diamond, now my home.
This frozen thrilling air my lungs have learned to breathe.
These hands, serene as water birds, that know no need
To reach or take or love or kill.
 All burn a silent
Praise of thanks to what or who has worked such peace.

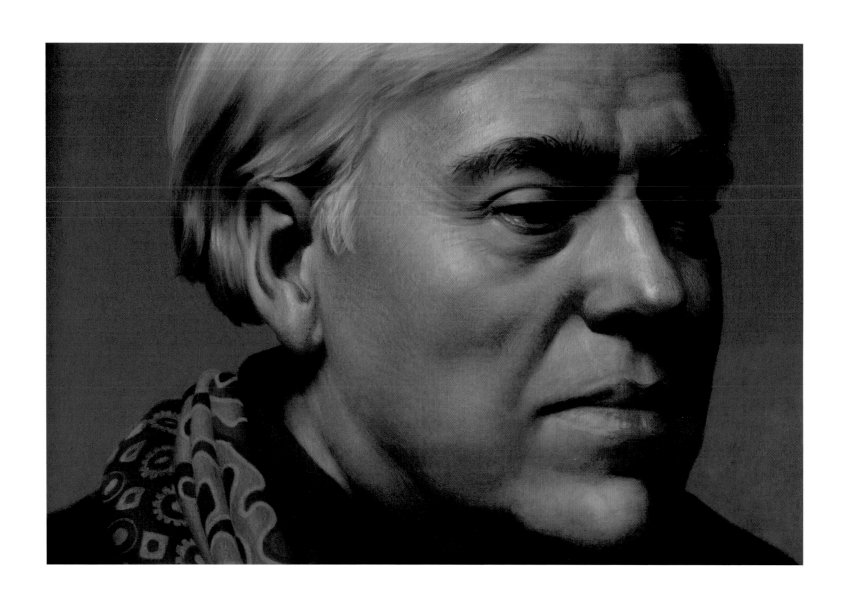

Afterword and Acknowledgments

IF ALEX AND I UNDERSTOOD in outline the truths expressed in *Dream of a House* before knowing Reynolds Price, it was Reynolds who, over the years, painted in the colors, with shade and nuance. Our greatest gratitude goes to him.

My friendship with Reynolds Price began in the mid-1980s, soon after Alex and I married and not long after Reynolds was confined to a wheelchair as the result of radiation treatment he received for spinal cancer. I never knew Reynolds as a physically upright person. Yet, of all the people I have known, he is one whose intellectual and artistic stature was monumentally impressive. Yes, he could dominate a table or a room, but he made good use of the platform—storyteller extraordinaire, erudite but never elitist, a wise man, generous of heart and in spirit, if not always in sharing the limelight.

As it turns out, Alex and I are good at appreciating brilliance. Whether in cooks or carpenters, artists or academics, or the everyday banter of a comedic bartender, we are awed by originality, aptitude, and exceptional optimism. We can agree to overlook the human flaws that co-exist with such traits. After all, a certain amount of arrogance tends to come with the territory. And if brilliance is tempered with self-awareness and leavened by a sense of humor, we *relish* the role of audience. Our friend Reynolds Price was unquestionably brilliant. He was handsome and charming and gifted, and he knew it. He was also profoundly sensitive, or maybe it was sensitively profound, or both, and it showed. All the time.

When I first got to know him, I was in my mid-twenties and more than a little frightened by the immensity of my hopes and dreams for a fulfilling life. Reynolds was in his mid-fifties, around the age I am now. Reynolds, by that time, had achieved tremendous success, but he had endured losses and survived both. Then, he survived cancer. He comprehended to his core the essential importance of home and family, the necessity of reliable friendship, how in every breath we should welcome and acknowledge the unbidden power of grace. But early on he also began to recognize hard facts that most of us resist for years, if not decades

or lifetimes: That living well is a complicated and conscious endeavor, that the so-called trivialities of life can serve as an antidote to that which feels too serious to bear, that relationships of any kind require both commitment and compromise, and that a partnership in love often boils down to the granting and honoring (by people of sound mind) of the right to use and be made use of by another.

He was, as everyone knew, intolerant of prejudice in any form, but he was also old-fashioned, hardwired to certain Southern rituals, and not just in his religious beliefs. For whatever reasons, none of them having to do with his respect for me or my work, he always referred to Alex and me together as "The Harrises," though he knew I had not assumed Alex's surname. And once, introducing me to a packed room for a reading from my memoir, *Miss American Pie* (2006), he referred to me as a "swizzle stick of a girl." (I was thin, but I was also over forty.) It was the kind of joke someone from my family might make, and it delighted me. This in itself was a gift because, in the simplest terms, Reynolds Price showed me that being Southern, irrevocably religious, and overly polite, with an uncontained curiosity for people, their stories, and an appetite for deep-fried food, was not synonymous with a lack of intellectual rigor. The picture Reynolds painted as a way to live was refreshingly honest and charitable with a healthy dose of hedonism. It still looks good to me.

So, in 2011, we lost him. I'm still sad about that. Sad that I didn't get around to sending him that postcard of Vivian Leigh I purchased in a bookstore in L.A., sorry I didn't see him during those last, excruciatingly painful months of his life. But grateful that, as Alex tells in his essay, we found him again one night in 2012, in a shared dream. When I think of that night, it is more as a visitation than a dream, a conjuring that he and we had somehow agreed upon. And, now, there is this book, which, we hope, opens other people's eyes to the richness of life that occupied and preoccupied Reynolds Price. This book, our loving farewell, is not compensation for the loss we feel, but it is some consolation, the best we know how to offer to him, to each other, and to all of you who have now shared in his world.

As Alex writes in his essay, the book started with William (Bill) Price and Daniel Voll inviting Alex in 2011 to make photographs of Reynolds's home after he died, before the inevitable process of dismantling had begun. Later, in 2013, after reading and searching through Reynolds's published work and interviews, Alex and I began to pick out quotes and match them with photographs, to see what kind of chemistry occurred. Eventually, we created a sequence of images and words, at first overly long and unclear in purpose but with a rhythm, a heartbeat. We showed this rough sequence to some of the people who knew him best. There was hearty encouragement and suggestions. We made revisions. In the next draft, Reynolds's voice gained clarity and resonance, the arc of his story was more dense but also more refined. Later, others read and commented on Alex's text to the book. In final revisions, with the excellent feedback and expert suggestions of Alexa Dilworth and George F. Thompson, Alex and I polished it smooth, and, it seemed to us, a kind of diamond emerged, something clear and true. Or that is what we hope. We know for certain that it is true to the Reynolds Price we knew.

Alex and I are extremely grateful to the people who played specific roles in bringing this project from idea to book. Bill Price offered all kinds of help by sharing his insights and deep knowledge of his brother's life and work, essentially guiding and blessing the process from beginning to end. Daniel Voll had the foresight to see that the house should be documented, and he continued to offer his feedback, vision, and encouragement throughout. Jeff Anderson, Rachel Davies, Edmond Miller, Karen McPhaul, Cecilia Peck, and Wil Weldon, friends who knew Reynolds and his home intimately, commented on different drafts of the book. Our agent, Emily Forland, was on board from the beginning, as always, with her clear-eyed critique and unfailing support.

We want to thank those who provided financial support, without which this book could not have happened: Bill Price; Daniel Voll and Cecilia Peck; James Schiff, who wrote the seminal book on Reynolds Price, *Understanding Reynolds Price* (1996); and the Robert C. and Adele R. Schiff Family Foundation; and Michael Jordan, one of Reynolds's oldest friends from their shared days at Oxford.

It is extraordinary to have a thirty-some-year association with the Center for Documentary Studies at Duke University. At CDS and CDS Books, we especially thank Tom Rankin, Iris Tillman Hill, Wesley Hogan, Lynn McKnight, and Alexa Dilworth, all of whom embraced the idea of this book. Alexa played an especially key role by providing insight into the structure and content of the book as well as reviewing the book's texts.

George F. Thompson, our other distinguished publisher, has a rare ability to see what is essential to a visual book and urged us in the right directions regarding the final evolution of the sequence and texts. We also thank Mikki Soroczak, George's assistant, and the gifted designer David Skolkin, who worked closely with us to create the kind of book we hope Reynolds would have wanted and loved.

Lauren Henschel researched and compiled the sources for *Works Cited* and *Books by Reynolds Price*. She took on what became a detective's task to find the respective copyright for each of Reynolds Price's texts and request the many permissions this book required. Marie Elizabeth Price (known as Memsy), as an executor of Reynolds Price's literary estate, alongside her father, Bill Price, helped to facilitate the publication of the excerpts we chose and advised us on the practical issues involved.

At the Duke University Libraries, we thank Deborah Jakubs, the University Librarian, who enthusiastically supported this book from the start and helped to make it a reality; Will Hansen, Curator of the Reynolds Price Archive in 2011, for patiently waiting to transfer materials from the house to the archive until Alex completed taking the photographs for this book; Sara Berghausen, Curator of the Reynolds Price Archive in 2016, for her work to organize an exhibition in the Rubenstein Library about Reynolds Price at Duke, an exhibition to be shown concurrently in 2017 with one at the Rubenstein Photography Gallery organized by Lisa McCarty, Curator of the Archive of Documentary Arts at the Rubenstein Special Collections Library.

And, finally, to our old friend Reynolds Price, we express our heartfelt gratitude for his ongoing presence in our lives.

Margaret Sartor

Works Cited

Editorial notes: All text excerpts and poems from Reynolds Price's work, as cited below, appear in their original form—that is, all spelling, punctuation, italicization, indentation, and capitalization have been confirmed with original archival sources—and they are reproduced with the permission of the respective publishers and institution. A few inconsistencies remain in Mr. Price's use of the singular possessive and capitalization. Also, in accordance with the original archival sources, all line breaks in the poems cited have been retained, whereas line breaks in the text excerpts are random, although careful attention was given to their form on the designed page.

9 Reynolds Price, *A Palpable God: Thirty Stories Translated from the* Bible*, with an Essay on the Origins and Life of Narrative* (New York, NY: Atheneum, 1978), 15.

11 Unpublished interview with Reynolds Price (Durham, NC: Center for Documentary Studies, 1987).

13 Jefferson Humphries, ed., *Conversations with Reynolds Price* (Jackson, MS: University Press of Mississippi, 1991), 263.

14 Ibid., 83–84.

16 Reynolds Price, "Homeless. Home.," in *A Common Room: Essays 1954–1987* (New York, NY: Atheneum, 1987), 230–42; as quoted on 233.

18 Reynolds Price, *A Whole New Life: An Illness and a Healing* (New York, NY: Scribner, 1994), 63.

20–21 Reynolds Price, "The Dream of a House," in *The Collected Poems*, 5–7.

25 Reynolds Price, "Introduction," in Larry Kramer, *Faggots* (New York, NY: Grove Press, 1978), xi–xvi; as quoted on xiii.

26 Reynolds Price, "Back," in *The Collected Poems*, 270.

30 Reynolds Price, "The Look of Hope," in Alice Rose George and Lee Marks, eds., *Hope Photographs* (New York, NY: Thames and Hudson, 1998), 161–72; as quoted on 171–72.

33 Reynolds Price, "A World to Love at Least," in *A Common Room*, 385–88; as quoted on 387.

37 Price, *A Palpable God*, 46.

38 Humphries, *Conversations with Reynolds Price*, 96–97.

41 Reynolds Price, *Clear Pictures: First Loves, First Guides* (New York, NY: Atheneum, 1989), 217.

45 Reynolds Price, "Anniversary, 9 January 1995," in *The Collected Poems*, 398.

46 Price, *A Whole New Life*, 192.

48 Price, *A Palpable God*, 3.

52 Reynolds Price, "Crossing Genders," in Reynolds Price, *Feasting the Heart* (New York, NY: Scribner, 2000), 121–23; as quoted on 122; originally aired on National Public Radio (October 1998).

55 Reynolds Price, "News for the Mineshaft," in *A Common Room*; originally published as an afterword in Reynolds Price, *A Generous Man* (New York, NY: Atheneum, 1966), 40–53; as quoted on 43.

56 Unpublished interview with Reynolds Price (Durham, NC: Center for Documentary Studies, 1987).

59 Humphries, *Conversations with Reynolds Price*, 18.

62 Reynolds Price, "A Final Account," in Reynolds Price, *The Collected Stories* (New York, NY: Atheneum, 1993), 519–24; as quoted on 520.

65 Reynolds Price, "Michael Egerton," in ibid., 104–10; as quoted on 104.

68 Humphries, *Conversations with Reynolds Price*, 24–25.

71 Ibid., 169–70.

73 Reynolds Price, "The Ghost-Writer in the Cellar," in *Feasting the Heart*, 27–29; as quoted on 28; originally aired on National Public Radio (October 1995).

75 Reynolds Price, *A Long and Happy Life* (New York, NY: Scribner, 1962), 1.

77 Reynolds Price, "Finding Work," in *A Common Room*, 15–19; as quoted on 19.

79 Price, *A Whole New Life*, 192.

80 Reynolds Price, "Dodging Apples," in ibid., 183–95; as quoted on 185.

84 Reynolds Price, "Available Heroes," in ibid., 289–93; as quoted on 292.

89 Jill Krementz, ed., *The Writer's Faith: 2005 Calendar* (New York, NY: Barnes and Noble, 2004), frontispiece for February; originally published in Dannye Romine Powell, *Parting the Curtains: Interviews with Southern Writers* (Winston-Salem, NC: John F. Blair Publishing, 1994), [page 268].

90 Reynolds Price, "15 March 1987 (to W.S.P.)," in *The Collected Poems*, 281.

93 Reynolds Price, "Seafarer," in ibid., 14–16; as quoted on 15.

94 Price, *A Whole New Life*, 43.

99 Humphries, *Conversations with Reynolds Price*, 276.

100 Price, *Clear Pictures*, 17.

103 Reynolds Price, "The Dream of Me Walking," in *The Collected Poems*, 369.

107 Reynolds Price, "Farewell with Photographs," in ibid., 345.

137 Reynolds Price, "Thanks," in *The Collected Poems* (New York, NY: Scribner, 1999), 299.

Books by Reynolds Price

FICTION

A Long and Happy Life (Atheneum, 1962)

The Names and Faces of Heroes (Atheneum, 1963)

A Generous Man (Atheneum, 1966)

Love and Work (Atheneum, 1968)

Permanent Errors (Atheneum, 1970)

The Surface of Earth (Atheneum, 1975)

The Source of Light (Atheneum, 1981)

Mustian: Two Novels and a Story (Atheneum, 1983)

Kate Vaiden (Atheneum, 1986)

Good Hearts (Atheneum, 1988)

The Tongues of Angels (Atheneum, 1990)

The Foreseeable Future (Atheneum, 1991)

Blue Calhoun (Atheneum, 1992)

The Collected Stories (Atheneum, 1993)

The Promise of Rest (Scribner, 1995)

Roxanna Slade (Scribner, 1998)

A Singular Family: Rosacoke and Her Kin: Three Novels and a Story (Scribner, 1999)

A Perfect Friend (Atheneum, 2000)

Noble Norfleet (Scribner, 2002)

The Good Priest's Son (Scribner, 2005)

NON-FICTION

Things Themselves: Essays & Scenes (Atheneum, 1972)

A Palpable God: Thirty Stories Translated from the Bible, with an Essay on the Origins and Life of Narrative (Atheneum, 1978)

A Common Room: Essays 1954–1987 (Atheneum, 1987)

Clear Pictures: First Loves, First Guides (Atheneum, 1989)

A Whole New Life: An Illness and a Healing (Atheneum, 1994)

Three Gospels (Scribner, 1996)

Learning a Trade: A Craftsman's Notebook, 1955–1997 (Duke University Press, 1998)

Letter to a Man in the Fire: Does God Exist and Does He Care? (Scribner, 1999)

Feasting the Heart (Scribner, 2000)

A Serious Way of Wondering: The Ethics of Jesus Imagined (Scribner, 2003)

Letter to a Godchild: Concerning Faith (Scribner, 2006)

Ardent Spirits: Leaving Home, Coming Back (Scribner, 2009)

Midstream: An Unfinished Memoir (Scribner, 2012)

POETRY

Vital Provisions (Atheneum, 1982)

The Laws of Ice (Atheneum, 1986)

The Use of Fire (Atheneum, 1990)

The Collected Poems (Scribner, 1997)

PLAYS

Early Dark (Atheneum, 1977)

Private Contentment (Atheneum, 1984)

New Music (Theatre Communications Group, 1990)

Full Moon (Theatre Communications Group, 1993)

About the Editors

Alex Harris is a photographer, writer, and teacher. He has photographed for extended periods in Cuba, the Inuit villages of Alaska, the Hispanic villages of northern New Mexico, and across the American South. He is Professor of the Practice of Public Policy and Documentary Studies at Duke University and has taught at Duke for more than three decades. At Duke, Harris is a founder of the Center for Documentary Studies (1989) and *DoubleTake* magazine (1995). His awards include a John Simon Guggenheim Memorial Foundation Fellowship in Photography, a Rockefeller Foundation Humanities Fellowship, and a Lyndhurst Prize. Harris's work is represented in major photographic collections, including the J. Paul Getty Museum in Los Angeles, the High Museum of Art in Atlanta, the Metropolitan Museum of Art in New York City, the North Carolina Museum of Art in Raleigh, and the San Francisco Museum of Modern Art. His photographs have been exhibited widely, including two solo exhibitions at the International Center of Photography in New York City. As a photographer and editor, Harris has published seventeen books, among them *A World Unsuspected: Portraits of Southern Childhood* (North Carolina, 1987), *River of Traps: A New Mexico Mountain Life* (New Mexico, 1990), with William deBuys, which was a finalist for the 1991 Pulitzer Prize in general non-fiction, *The Idea of Cuba* (New Mexico, 2007), and *Why We Are Here: Mobile and the Spirit of a Southern City* (Liveright/Norton, 2012), with Edward O. Wilson.

Margaret Sartor is a writer, photographer, editor, and curator. For many years, she has taught courses in memoir writing and documentary photography at Duke University. In her work, Sartor examines and explores the essential human questions of identity and belonging, especially in relation to family, faith, and place. Her four published books include *Gertrude Blom: Bearing Witness* (North Carolina, 1984), co-edited with Alex Harris, *What Was True: The Photographs and Notebooks of William Gedney* (Center for Documentary Studies/Norton, 1999), co-edited with Geoff Dyer, and the memoir *Miss American Pie: A Diary of Love, Secrets, and Growing Up in the 1970s* (Bloomsbury, 2006), which was a *New York Times* best-seller, a *Washington Post* Critics Choice Memoir, and a *Chicago Tribune* Best Book of the Year. Her photographs have appeared in numerous books and periodicals, among them *In Their Mother's Eyes: Women Photographers and Their Children* (Editions Stemmle, 2001), edited by Martina Mettner, *Black: A Celebration of Culture* (Skyhorse, 2014), edited by Deborah Willis, *Aperture, DoubleTake, Esquire, Harper's, The New Yorker,* and *The Oxford American.* Her photographs have been exhibited widely and are in permanent collections, including the Museum of Fine Arts, Houston, the North Carolina Museum of Art in Raleigh, and the Ogden Museum of Southern Art in New Orleans. As a curator, Sartor has worked with Duke University, the International Center for Photography in New York City, and the San Francisco Museum of Modern Art.

About Reynolds Price

Reynolds Price was born in Macon, North Carolina, on February 1, 1933, the first of two sons. Educated in the public schools of his native state, he earned an A.B., summa cum laude, from Duke University. In 1955, he traveled as a Rhodes Scholar to Merton College, Oxford University, to study English literature. After three years and receiving the B.Litt. degree, he returned to Duke, where, for more than fifty years, he continued teaching as the James B. Duke Professor of English. With his novel *A Long and Happy Life*, which won the William Faulkner Award in 1962, he began a career that resulted in forty-one subsequent volumes of fiction, poetry, plays, essays, memoirs, and translations. His novels include *Kate Vaiden*, winner of the National Book Critics Circle Award for fiction in 1986, and his work has been translated into seventeen languages. He received a John Simon Guggenheim Memorial Foundation Fellowship for Creative Arts in 1964, and he was a member of both the American Academy of Arts and Letters and the American Academy of Arts and Sciences. Price died on January 20, 2011, in Durham, North Carolina.

About the Book

Dream of a House: The Passions and Preoccupations of Reynolds Price was brought to publication in an edition of 1,500 hardcover copies, of which 100 are issued in a limited signed, numbered, and slipcased edition. The text was set in Requiem, the paper is Lumisilk, 170 gsm weight, and the book was professionally printed and bound by Pristone in Singapore.

Publisher and Project Director: George F. Thompson
Editorial and Research Assistant: Mikki Soroczak
Editor and Proofreader: Purna Makaram
Book Design and Production: David Skolkin

Special Acknowledgments: The painting in Alex Harris's photograph that appears on page 27 and on the back cover is "Night" by Juliette Aristides (b. 1970), oil on canvas, 16 x 22 inches; the frame is parcel-gilt and painted wood. The publisher also extends special gratitude to Alexa Dilworth, Publishing and Awards Director and Senior Editor of CDS Books at the Center for Documentary Studies at Duke University; Emily Forland, literary agent at Brandt & Hochman in New York City; Lauren Henschel, a research assistant at Duke University; and everyone else at Duke and the Center for Documentary Studies, including the donors, who made this book possible.

Note about the Exhibition: An exhibition of selected photographs by Alex Harris and text excerpts by Reynolds Price from this book was held at Duke University's Rubenstein Library from July through November 2017, with a special event held on September 28.

Copyright © 2017 Alex Harris, Margaret Sartor, and George F. Thompson Publishing, L.L.C., except as follows: Photographs and "Farewell with Photographs" by Alex Harris © Alex Harris and "Afterword and Acknowledgments" by Margaret Sartor © Margaret Sartor. All rights reserved. No part of this book may be used, reprinted, or reproduced in any form or medium or by any means without the written consent and permission of the publisher and the editors.

Published 2017. First hardcover edition.
Printed in Singapore on acid-free paper.

George F. Thompson Publishing, L.L.C.
217 Oak Ridge Circle
Staunton, VA 24401-3511, U.S.A.
www.gftbooks.com

25 24 23 22 21 20 19 18 17 1 2 3 4 5

The Library of Congress Preassigned Control Number is 2016962948.

ISBN: 978-1-938086-49-6